THE BATHROOM CHRONICLES
100 WOMEN. 100 IMAGES. 100 STORIES.

Edited by Friederike Schilbach

BLACK DOG
& LEVENTHAL
PUBLISHERS
NEW YORK

Black Dog & Leventhal Publishers
Hachette Book Group
1290 Avenue of the Americas
New York, NY 10104

www.hachettebookgroup.com
www.blackdogandleventhal.com

Originally published in German in 2017 by Suhrkamp Verlag Berlin

First English-language Edition: September 2018

Black Dog & Leventhal Publishers is an imprint of Hachette Books,
a division of Hachette Book Group. The Black Dog & Leventhal Publishers name
and logo are trademarks of Hachette Book Group, Inc.

Library of Congress Cataloging-in-Publication Data has been applied for.

ISBNs: 978-0-316-48569-2 (hardcover); 978-0-316-48568-5 (ebook)

Printed in China

1010

10 9 8 7 6 5 4 3 2 1

CONTENTS

INSIGHTS INTO SECRET CHAMBERS

The idea for this book first occurred to me when I was staying with a friend in Italy. Over the summer months she decamps to Monopoli, a little seaside town where she has an apartment that once belonged to a ship's captain. My friend renovated it herself, taking great care over the details. The spot where there used to be fireplace with a chimney is now the bathroom. When you step into the shower, you can look up a three-foot-long shaft to see a slice of clear sky at the top, high above your head, like a James Turrell light installation.

This bathroom resembles my friend's very character: cool, open, minimalistic, and beautiful. And so that summer, just before I left, I asked her to send me a picture of it as a souvenir. She did just that, and added a couple of vivid sentences about it. Back in Berlin I asked a few more of my friends—only four or five at first—whether they, too, would mind sending me a photo of their bathrooms. Almost all of those friends put me in touch with other friends of theirs, whose bathrooms they felt simply had to feature in my growing collection. And so, day after day, emails flooded in with photos and little stories about yucca plants, souvenirs from around the world, and glamorous grandmothers. In no time, I had over a hundred photos and notes telling me all about the women who had taken them. In November of last year, I gathered the images together and put them on display at Melanie dal Canton's shop MDC in Knaackstraße, Berlin, in an exhibition that we called *The Bathroom Chronicles*. And now they've been reunited in this book.

I have always found bathrooms more interesting than kitchens or bedrooms. It's a place where you come face-to-face with yourself, reflected in the mirror, as you brush your teeth, massage in creams, or fix your hair as you prepare for the day ahead or get ready to turn in for

the night. Of all places, it is here that many of my girlfriends keep things that are dear or precious to them—small objects that hold emotional resonance for them: photos, flowers, jewelry, family keepsakes, vintage finds, books, postcards, vials, perfumes, old towels, little mermaids, rubber whales, hourglasses, creams, vases, plants, ceramic pots, magazines, and lipsticks. This is an intimate space—perhaps the most intimate in the whole home. It's where they shake out their lives, take a good look at themselves after getting up or before going out, construct their identity, and fashion a sense of self. Maybe that's why I like hanging out in their bathrooms so much: because I feel that something of their magic, their daily rituals, lingers there, just within reach.

One friend who now lives in Tokyo sends me a small bottle of Johnson's Baby Cologne every year. She gets it from the drugstore; it's scented water for babies, no more sophisticated than that. She knows how much I love these simple fragrances and how much they remind me of our childhood together and of her mother, who used to always bring along this scent when she came to see us. Another friend loves to look around my bathroom, trying out this perfume or that new lipstick. When I'm at her place I do exactly the same thing and invariably want to take everything in her bathroom cabinets away with me—as though these items might allow me to always have a bit of her with me, no matter how far apart we might be.

Not all of the women in this book are my friends, but we're all connected, as friends of friends. They range in age from twenty to seventy-five. Some live in the countryside, while many others dwell in cities like New York, London, Tokyo, Johannesburg, or Berlin. Some of their pictures are snapshots of their day-to-day lives, while others are carefully staged. All of them explain in their own words what these scenes mean to them. The result is an array of insights into the secret chambers of their lives—one hundred everyday portraits distilled down to the details.

—*Friederike Schilbach*

THE BATHROOM CHRONICLES
100 WOMEN. 100 IMAGES. 100 STORIES.

EMMA PATERSON

London

I like showering almost as much as I like sleeping—it's one of the few instances where the body seems to override the worries of the mind. Unsurprisingly, then, the bathroom is one of my favorite places in the house. It has so many primal gifts to offer: warmth, solitude, a space of one's own. I get stressed if it starts to feel too cluttered, and limit myself to the basics: shampoo, conditioner, and maybe a luxury face peel that promises to turn back the years. Alongside those sit my handmade pineapple (a wedding present) and my favorite toothbrush, which you can see and judge me for here. My husband's first nickname for me was "Pineapple" because of the way I wear my hair.

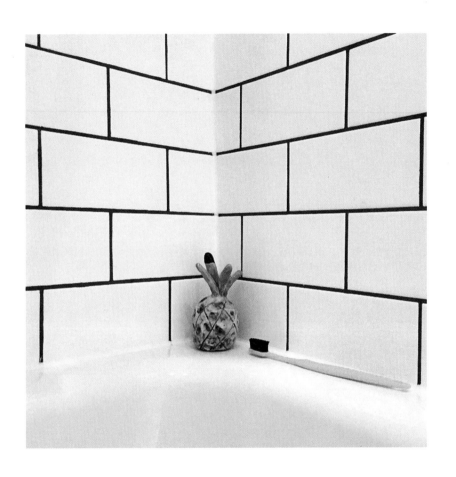

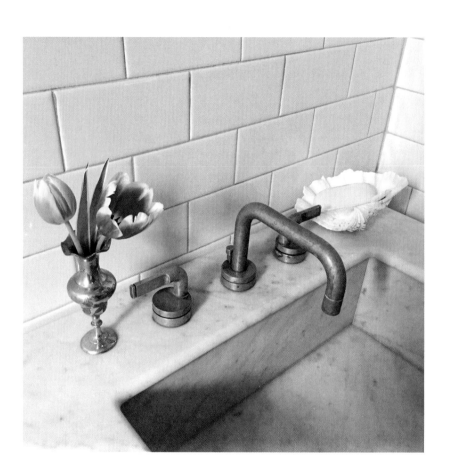

AGNES BARLEY

New York City

This is a picture of my petite but beloved sink. The sink is for me at its most beautiful when it is uncluttered and clear. The soap in the shell and the flowers change regularly throughout the year and the change in seasons.

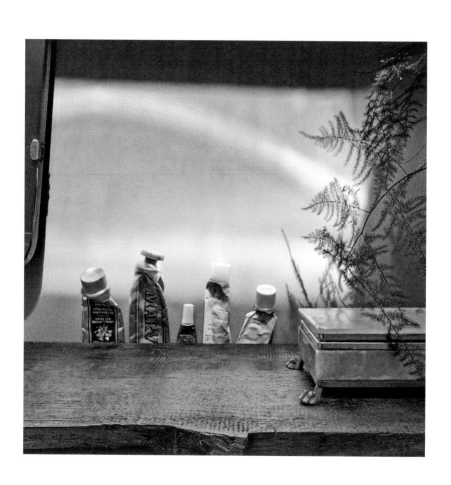

IMKE JUROK

Hamburg

In my bathroom there's a casket with lion's feet, which I bought at a flea market in southern Italy. It was originally intended for our holiday apartment in Monopoli, Puglia, but it ended up coming back with us to Hamburg, where we live most of the time. The casket contains nothing but a few rusty hair clips, safety pins, stray buttons, and a stub of kohl, but it still reminds me of hanging washing on the roof every day, the sound of the neighbors yakking away, and drinking wine with lunch—there's nowhere quite like Italy.

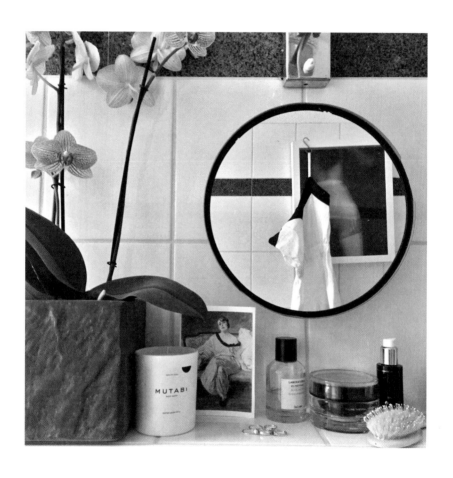

MIRNA FUNK

Berlin/Tel Aviv

I love my bathroom. I love getting ready in there for the day ahead but
also making myself up for an evening out. Every night I take off the rings
that I inherited from my grandmother: one with pearls, one with a dia-
mond, and one with a ruby. I bought the postcard that is propped up
beneath the mirror at the Tel Aviv Museum of Art. It shows my great-
grandmother Lola Leder. Max Liebermann painted her portrait quite
a few times, and there are several of his paintings in the museum. Both
women—my grandmother and my great-grandmother—are very impor-
tant to me. They shaped my sense of what it is to be a woman and con-
tinue to do so to this day.

JUMAN MALOUF

Bearsted, Kent

My friend sent me the postcard. It's by an artist named Alfred Wallis. I sometimes think it will be the last postcard I'll receive in the post. Wallis worked on a ship as a child. He mostly painted boats with sails, maybe because they were being replaced by steamships. The postcard happens to be one of the steamships he dreaded.

My bathroom reminds me of a bathroom on an old boat—except maybe for the wallpaper. That looks like the garden in summer outside the window of the bathroom.

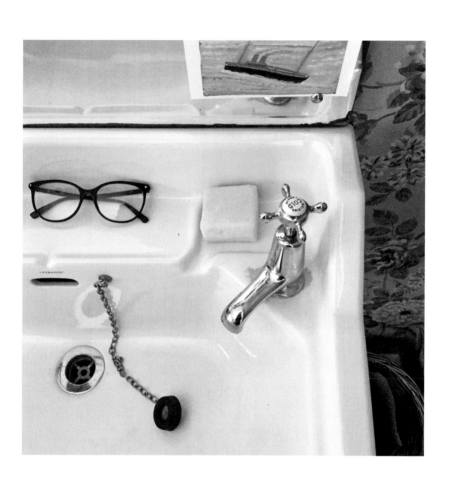

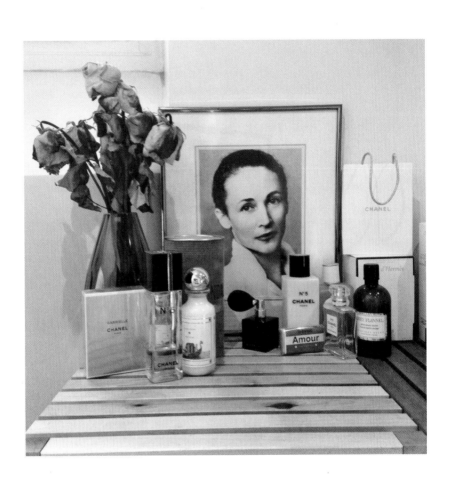

ANNABELLE HIRSCH

Paris

The lady in the photo is my French grandmother. As far as I was concerned, she was always the very image of a movie star. In fact, as a young woman she dreamed of becoming an actress. Some people from Paris once came all the way to her little fishing village in Brittany to do a screen test with her. In the end, her parents were against it and refused to let her move to Paris on her own. But she remained a coquettish woman her whole life and attached great importance to her appearance and her "toilette." Much to the chagrin of my grandfather, this meant spending the requisite amount of time in the bathroom. Every holiday I went to stay with her in Brittany and would always get up early to watch her make herself up: lipstick, powder, eyeliner, eyelash curlers—the whole old-style glamour look. The plethora of beauty products that now stand in front of her picture in my bathroom would certainly have made her happy. Most of them were gifts. One of my best friends from Munich was a beauty editor for a while and was always presenting me with bags of products. Another dear friend from Paris is a writer but works for Chanel during the day and brings me a little bottle of Chanel No 5 almost every time I have a party. The bottle of Grey Flannel in the corner is the one thing that belongs to my husband.

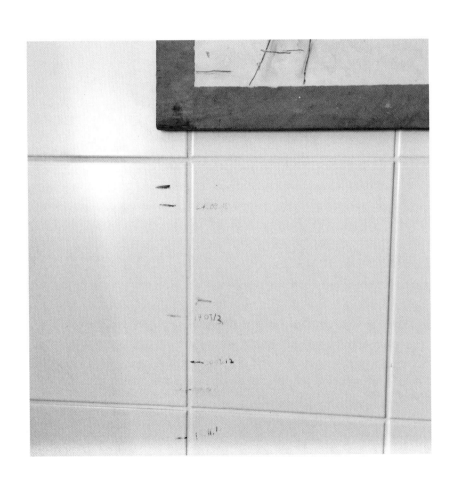

SABRINA DEHOFF

Berlin

The markings on the bathroom wall show how my son, who is now thirteen, has grown over the years. Ever since he could stand up, we've measured him against the wall, at completely random intervals. It tends to happen on the spur of the moment, after he's had a bath, so we use whatever we have on hand in the bathroom—eyeliner, lip liner, that sort of thing. Everyone is forbidden from wiping this section of the wall. If we ever move out, we plan to pull the tiles out and take them with us.

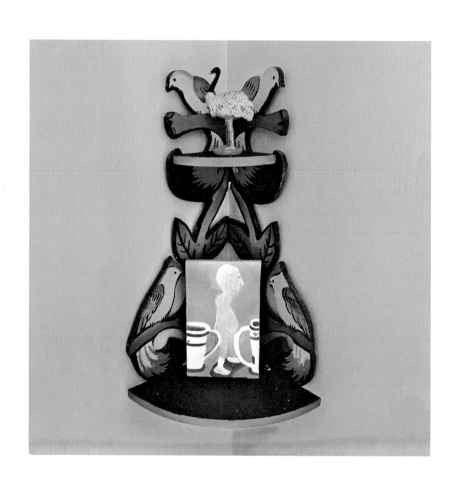

ROZ CHAST

New York City

This is a little shelf that lives in our bathroom upstairs. The shelf came from a secondhand store and is bird-themed, because I like birds. It holds a tiny emu that was given to me by a friend when I was in Australia, also because he knew I liked birds. The painting was done by my kid. He said that it symbolized him as a child, being supported by my husband and me, as he was learning to stand by himself. He may have been pulling my leg—I'm not sure. There are no birds in it.

LUCA GAJDUS

Berlin

At some point my boyfriend decreed that we needed "lots of houseplants around the place." This plant has stood beside the toilet ever since. It was a matter of some dispute between us from the very beginning, and there came a time when it folded over on itself and then died altogether. Maybe the bathroom was too warm for it? I always have to have my bathroom warm—it makes getting up so much easier in winter. Aside from that, I'm against houseplants as a matter of principle.

I like my bathroom best when my kids are having a bath in there. I sit on the floor beside the bathtub and watch the two of them playing. More and more water splashes out onto the floor. At first I protest, but it's not long before I end up joining in with the giggling and splashing.

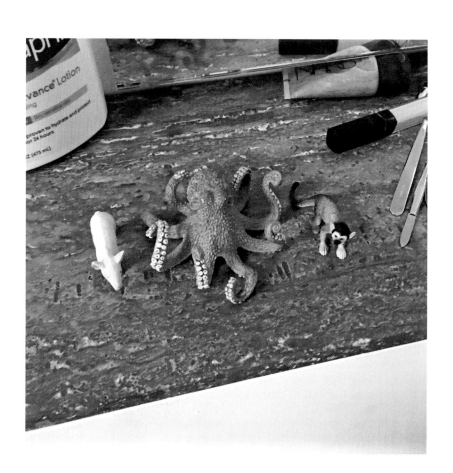

ALEXA KAROLINSKI

Los Angeles

These are my bathroom animals. I've developed an obsession with Schleich animal figurines. I usually pick one up traveling, killing time at the airport. Most of the time I'll get one for kids of friends. These three I kept for myself. The octopus is my favorite. I like its design and that it's much larger than the other two. Schleich also makes incredible dinosaur figurines, which I like to get for my godson, Ezra. Generally, I like a silly object here and there. Silly, because I'm a grown woman with three plastic toy creatures in her bathroom that I treat like serious art.

JASMIN SCHREIBER

Berlin

Sometimes I have visitors who go into my bathroom and wonder why I appear to have ten bottles of the same nail polish. But they've got it wrong—my collection is made up of completely different shades of pink, red, and orange. I put on the right nail polish for the kind of day that I have ahead of me.

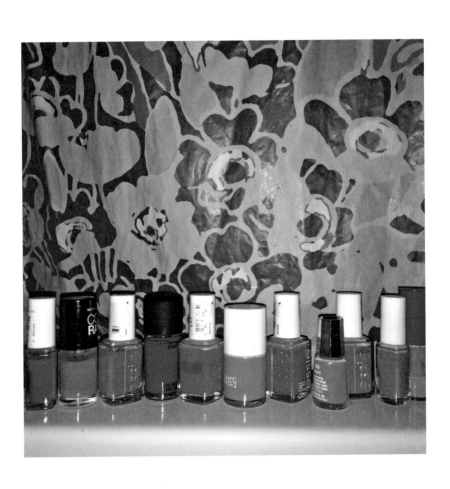

CORINNA BARSAN

New York City

I was never much of a "pink" girl, but there's something handsomely rough about the way these vintage floor tiles in my bathroom refuse to line up, and it's in that balance of feminine and masculine that I find myself standing atop imperfect perfection.

MARY SCHERPE

Berlin

The chubby girl is from Hawaii; I found her in the best thrift store for Hawaiian shirts in Honolulu. She was just standing there in the middle of a crowd of hula-hooping Obamas.

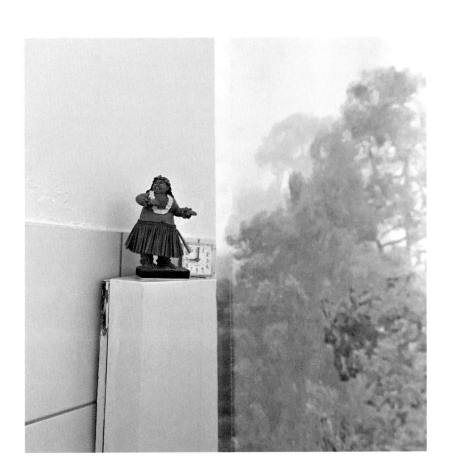

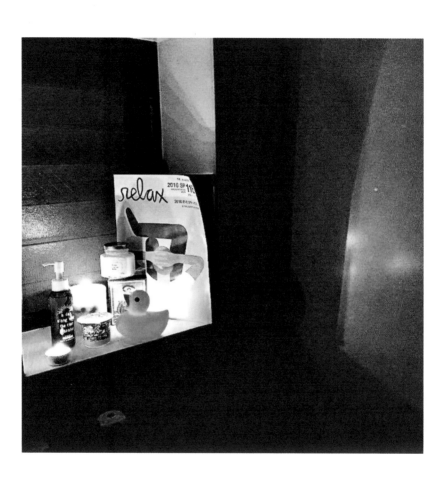

HARUKA HORI

Tokyo

I work in a wine bar, and when I come home late at night, I like to take a bath in the dark and wash away the day.

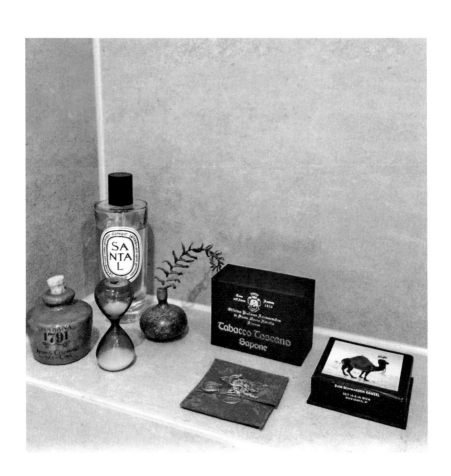

GILLIAN HENN

Berlin

My favorite spot in the bathroom is home to a tobacco-infused fragrance from Cuba, a Schwarzen Kameel box from Vienna, and a soap from the Farmacia di Santa Maria Novella in Florence. One thing that's just outside the frame is a small black travel radio tuned to my favorite station, Radio Paradiso. It provides the soundtrack to my morning.

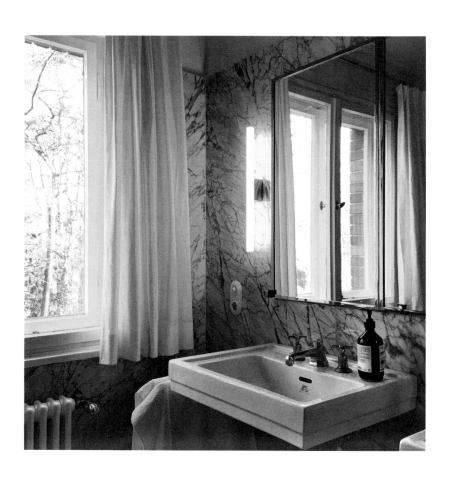

PHILOMENE MAGERS

Berlin

Our bathroom is a place of tranquility. I love spending time in there and clearing my head in the morning. The stone slabs on the walls give it a solid coolness, and when lying in the bath you can always make out new pictures in the patterns of the veins.

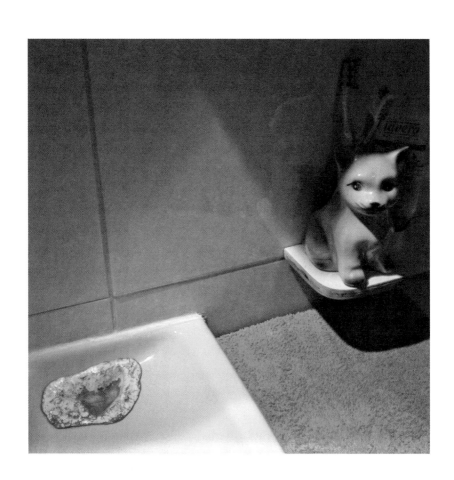

CHANTAL RENS

Tilburg

One night out of nowhere the bathroom mirror fell down. It created a hole in the washing table which, restored amateurishly by me, by chance turned into this semi-amorphous shape of a heart. Sometimes it holds a bar of soap or a scourer. The ceramic cat comes from a thrift store and is now my toothbrush holder.

ANA BOTEZATU

Berlin

The golden wall was not my idea. My boyfriend surprised me and one day I came home to the bathroom like this. I love everything that is golden, that flickers and shines, much like a crow, I guess. The bowl is from my home country, Romania. I didn't keep many things from there, but I find it interesting to take things out of their context. In Romania I would have never used a bowl like this, but it feels at home in my Berlin bathroom.

KATHARINA VON USLAR

Berlin

It's curious that this little corner doesn't get more attention, given that we use the things in it much more often than those elsewhere in the home. Actually, when I'm brushing my teeth I do often cast my eyes toward this newspaper clipping, which shows a nude photo of Madonna taken back when she had to work as a model in order to make a living. I framed it because in her gaze I can already see all that boldness and self-assurance that would later make her into my biggest idol. The little bowl where the most random things accumulate over time is also very important to me. Buried in this one, along with various pieces of jewelry, is a large white *K* with a jauntiness that makes it surprisingly similar to my signature, as well as a torn friendship bracelet from my daughter and a delicate little makeup brush that I never actually use but love to look at.

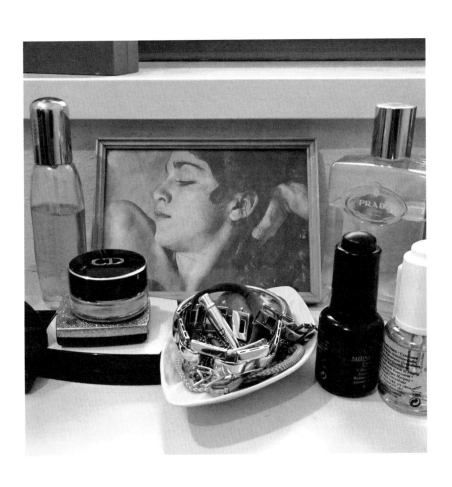

KATE GROOBEY

Paris

I am a painter. A bar of soap is part of my toolbox. A lot of painters are stuck in Freud's shit phase. We like to get dirty; ergo, we spend a lot of time washing. Painting is about dirt and about the hands and the body. And so is a bar of soap.

VERENA GÜNTNER

Berlin

My bathroom doesn't belong to me. It's the domain of Darth Vader and
Vic the Viking and his pals, with three bedraggled Barbies doing a stint
as bouncers. If I don't manage to make it past them, I console myself
with the thought that I've always preferred being outside in any case. I
grew up in a small house that was built up against the city walls. The
bathroom was in the attic and had a window on the back wall. I was
about fourteen when I was left in the house on my own for a few days
for the very first time. My mother made me promise that I wouldn't get
up to any mischief, and then made her departure, clearly in a state of
trepidation.

Five minutes after she left, all of my friends were over. The living
room floor was covered in mattresses, the fridge was packed with beer,
we had a stack of canned ravioli, and 24/7 MTV was playing away in the
background. At night, we slept in a tangled heap, clasping one another's
hands, exchanging the odd kiss. Since the next-door neighbor was
a friend of my mother's, we climbed through the bathroom window
and out onto the roof when we wanted to smoke. We tilted our feet to
the angle of the slope, and the boys took turns to balancing on the roof
ridge. Our Gauloises stubs, which we threw off the roof, soared in a high
arc through the air and plummeted fifty feet into the void. The people
in the houses opposite waved anxiously at us, and we blew them back
kisses, laughing.

These days when I pay my mother a visit and look out of that window,
I can't help but shudder. But back then I felt no fear: it was a beauti-
ful, carefree game, and I lived in the innocent belief that nothing could
happen to me or those around me. When I'm in an unfamiliar home, I
still always throw open the bathroom window and look upward. The
bathroom seems like an eternal passageway to that state of limbo that I
felt back then, poised as I was between home and freedom.

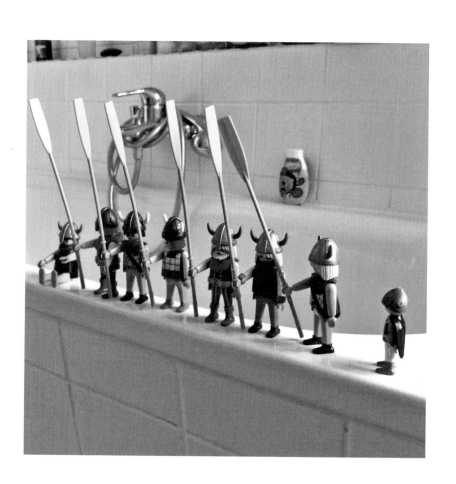

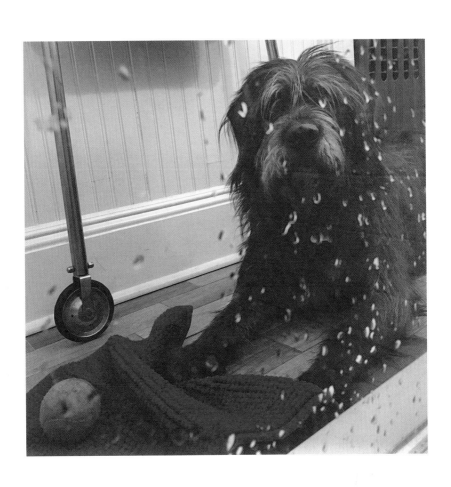

ARIELLE ECKSTUT

New York City

Arielle = Only Child

Only Child = a lot of alone time

Only Child + Husband = nice balance of companionship and alone time

Only Child + Husband + Child = time in bathroom only alone time

Only Child + Husband + Child + Dog = what's alone time?

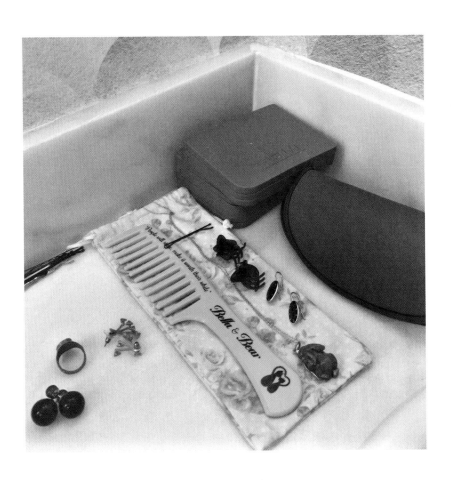

LENA DUNHAM

New York City

This picture shows the corner by the sink where I keep my favorite pieces of jewelry, ones that work with any outfit and add a quick touch of intentionality and polish, and also where I stockpile three months of birth control, so I never have to panic and run out.

NIKE VAN DINTHER

Berlin

My young son created this installation in our bathroom. I think he's made it look beautiful, even though he clearly thinks that Mommy uses tampons whenever she does a pee.

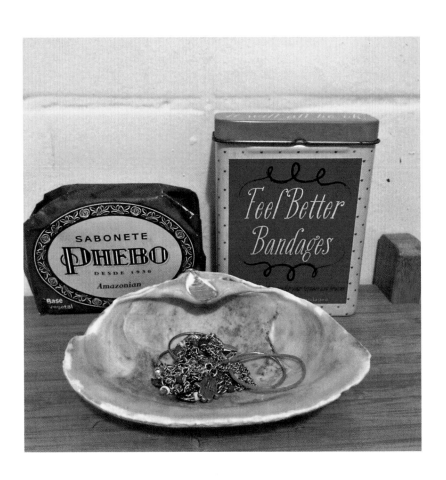

DENA

Berlin

Three favorite things in my bathroom that I look at every day to remind me that there's a world beyond the immediate here and now: a seashell that I found this summer in New York, on the shore of the Atlantic; a Brazilian soap that I've had for years—a highly personal, sentimental item; and bandages that I bought years ago in the US, which always brighten up my mood.

HANYA YANAGIHARA

New York City

This is part of my wall-mounted case of monsters and aliens in my guest bathroom; when men are in there using the bathroom, they're forced to look at this cabinet.

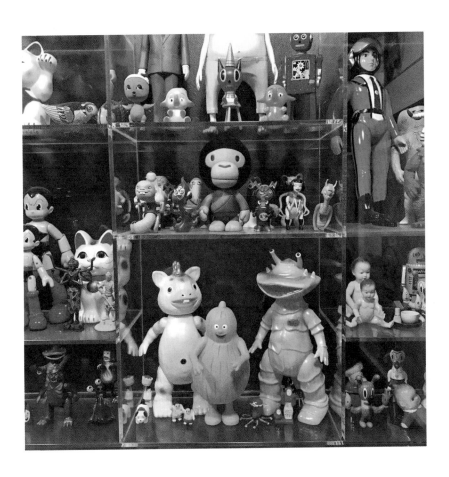

JULIA KNOLLE

Berlin

I took over this apartment from my friend Stephanie, who has a knack for interior design—something that I could never claim for myself. At some point, I saw this succulent—healthy back then—in its golden pot, and bought it. Shortly afterward, I added the two perfumes, which are really just there for decoration—I don't actually use scent. The fresh flowers are my new thing—seeing them in the morning makes me happy somehow. I used to live above a bar; the glass comes from there. The shower radio is a recent addition: the thought of spending the first thirty minutes of the day without being glued to my iPhone appealed to me.

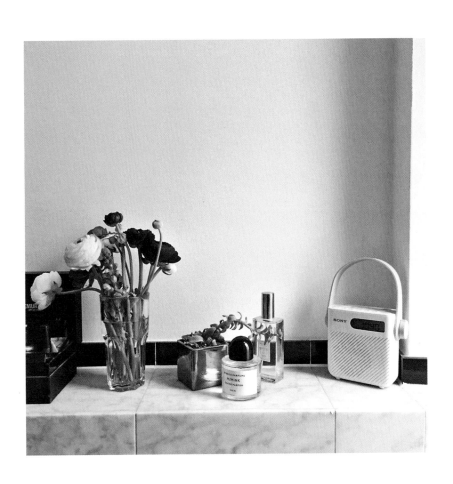

SHEILA HETI

Toronto

I never know which toothpaste to buy. Like wine, I can't remember which toothpastes I liked and which I did not. When my boyfriend brought a half-used tube of this back from a vacation in the Cayman Islands with his brother, I knew I wanted no other toothpaste ever. It's so pink and astringent! I ordered six boxes from eBay and store them on top of the cabinet above the toilet. I didn't realize how dusty it was up there until I took this picture.

JULIANE WÜRFEL

Leipzig

This picture was taken in my third shared apartment in Berlin. You get a sense of the spatial proximity of those sharing an apartment from the toothbrushes nestled together here, including those belonging to various partners and friends, who often stayed over.

NINA ZYWIETZ

Berlin

Apart from toothpaste, Weleda Skin Food is the only cream that I use. It's unctuous and has this wonderful smell of forests and fresh meadows. And there always has to be at least one book in the bathroom—at the moment it's Rafael Nadal's biography. I love tennis, and I find it inspiring.

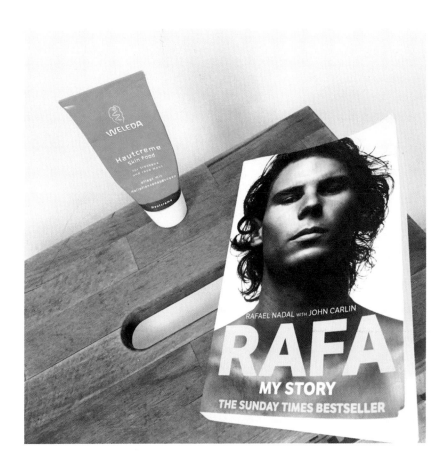

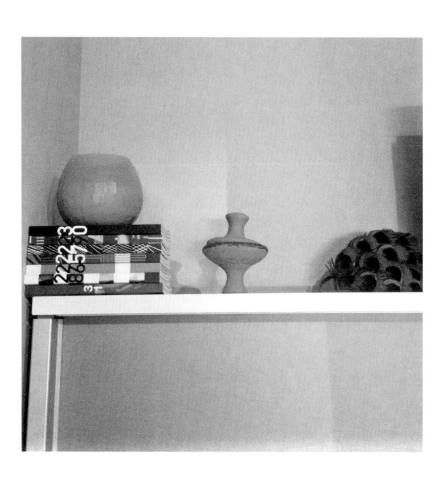

SONJA HEISS

Berlin

The peacock feather headband comes from a little hat store on Melrose Avenue in Los Angeles. My daughter June was about two and a half at the time, and really tiny. She kept putting on one hat after another, and her little head would completely disappear into each one. I love remembering that moment, because it made me laugh to see a little body running around the store with a hat instead of a head. The clay structure on the left is made up of a Moroccan callus stone and a Berber lip stain, which I put together. To use the lip stain, you just moisten your finger, rub it around the inside of the little clay bowl and then dab the red pigment onto your lips. It's a pure red, the kind you get with good nail polish. Of course, you then have the pigment not only on your lips, but also on your finger. That's why I've put the Berber lip stain on top. I don't use it. Both items were gifts; it always makes me smile to think that someone got me a callus stone as a present.

On the left is a small stack of *Revolver* magazines. I subscribed to this fabulous, gorgeous-looking little movie magazine for many years. There's a bigger stack of them elsewhere in my home. But I don't believe that anyone apart from me has ever taken one of these from the pile and read it. Are we allowed to talk about reading on the toilet? Or is that one of the last taboos still to persist?

ANNA WINGER

Berlin

I used to live in Mexico, where on a clear day I could see the volcano Popocatépetl from the bathroom. Since then, I know that a toilet with a view is an underestimated luxury.

Now I live in Berlin, where the master bathroom off our bedroom opens out onto a balcony that looks out over our garden and those of the neighbors.

A friend of mine leaves a pile of reading glasses in all strengths by the magazines in her Los Angeles bathroom to make up for the lack of a view, so that visitors never get bored.

By our summer house in Maine, there is an old fishing cabin. It must be a hundred years old. It is too close to the lake for plumbing, so there is no bathroom inside, just an outhouse a few paces away. The outhouse is very rustic. Since it's very private in the forest and there's no reason to close the door when you use it, we turned the outhouse around so that the door faces west over the lake. Now, when you sit there, you have a lovely view of the water. Everybody finds it very relaxing.

Our summer house up the road from the fishing cabin has a couple of perfectly good bathrooms, but at the end of a nice summer day, who wouldn't prefer to head down to the outhouse and contemplate the sunset over the lake?

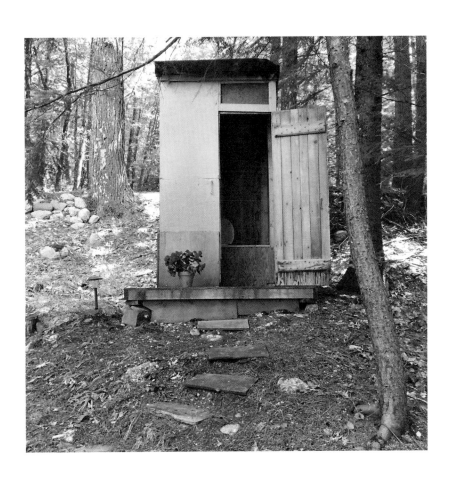

JULIA ZANGE

Berlin

Reading recommendation for the bathroom: must be
swiftly consumable,
Easily digestible,
But also edifying.
Apart from that,
Not a clue.

ELIF BATUMAN

New York City

Sometimes my heavy thoughts and ideas are out of proportion with the material conditions of lived existence.

BRITTA THIE

Berlin

Here you can see a soapy specter that appeared as I ran a bath. I squirted the bubble bath into the center, then swung it left and right to make a spiral. Suddenly an ominous spirit emerged, and I bathed in it.

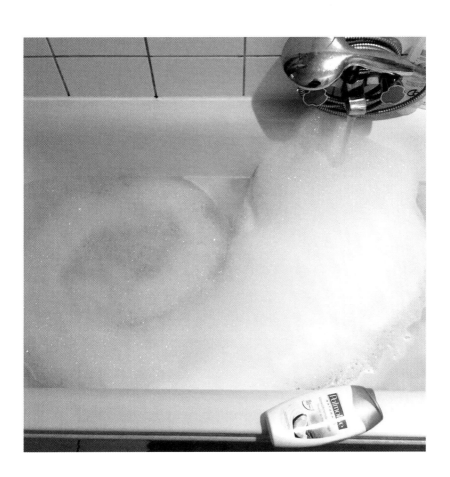

SARAH RALFS

Berlin

We don't have a shower, just a bathtub. But that would be my preference anyway, if I had to choose. When I still lived with my parents, I had a bath almost every day after going riding. It was heavenly after all that fresh air and the earthly smell of horse manure. Today our bathtub is still a protective, sheltered spot, especially when it's full of water and bubble bath; a place to warm up and recover from the often-bizarre Berlin day.

LEANNE SHAPTON

New York City

This picture shows my bathroom, looking toward the hallway. I love
Monica Vitti and in particular this picture of her, which I used as a prop
in my book *Important Artifacts…* One of the towels I found at a second-
hand store. I loved the purple colors and pattern. The other is an Hermès
beach towel. I love colorful towels; I only like white ones in hotels. I
hang my wet swimsuits on the back of my door after doing laps or taking
my daughter to swimming lessons at the YMCA. The blue and white one
is an old nylon Speedo with low-cut hips.

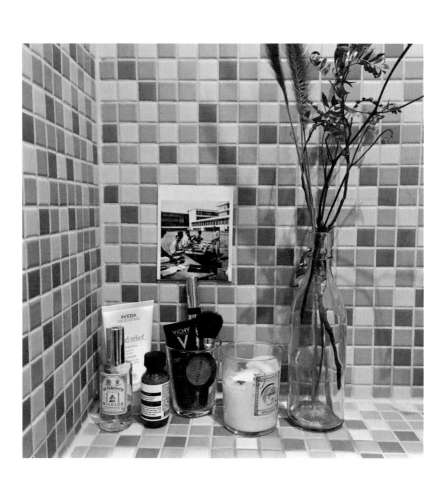

PAULINA CZIENKOWSKI

Berlin

These students from the Bauhaus in Dessau, back in 1932, smile at me in my bathroom. Most of the time I smile back at them, as though we're flirting with one another. And that's all I really need. Oh, and perhaps a little rouge, plus the scent of my favorite perfume.

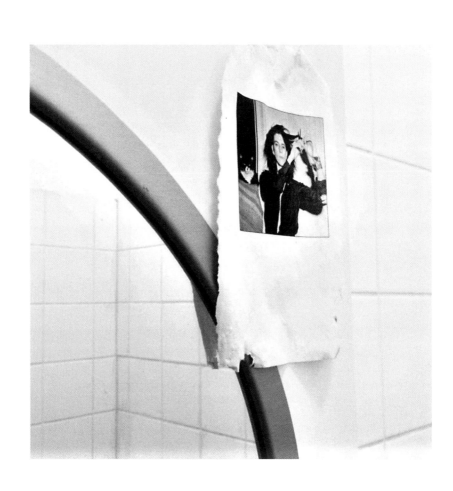

ALIZÉE LENOX

Berlin

Our dog Jinks used to eat books anytime we'd go out. One time, she ate the whole *Just Kids* by Patti Smith. Only this picture of Patti cutting her hair remained from the book.

We were amused by this and placed the page above the mirror.

KHETSIWE MORGAN

Johannesburg

I'm a DJ. My jewelry tree in the bathroom is the final inspiration to transforming into the goddess I am when getting ready for the night.

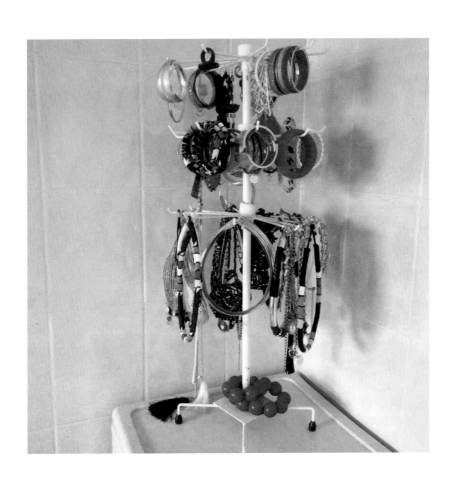

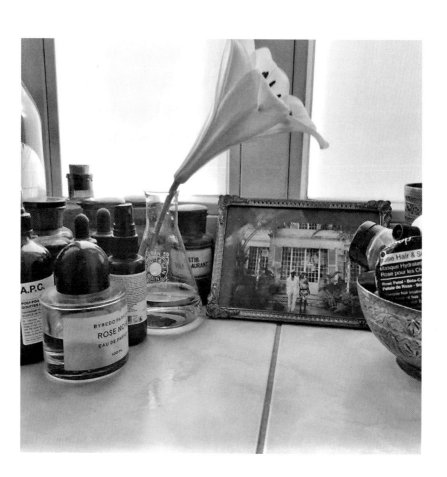

MALIN ELMLID

Berlin

On New Year's 2010, which I celebrated in Antwerp, I found a card on the street that said, "Happy Independence 2010." It was the fifty-year anniversary of independence of the Congo, a former colony of Belgium. The history of the Congo has been a chapter that has followed me since my teenage years and is still haunting me.

The year 2010 was also big for me: breaking up from a seven-year-long relationship, quitting my job in fashion, deciding to take my project the Bread Exchange seriously and see where it takes me. Good times ahead. The card talked to me directly.

I ended up taking it with me, turning it into my invitation card for my thirtieth birthday six months later, even going back from Berlin to Belgium to have the cards stamped and sent off from Brussels.

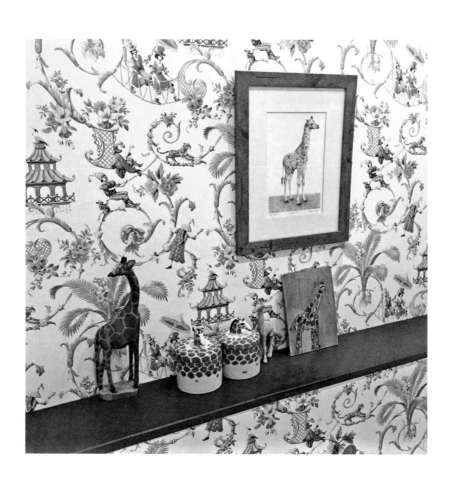

LISA FELDMANN

Berlin

At first it was just one drawing, ferreted out in a little vintage store in the south of England. A young giraffe. I snapped it up because it reminded me of a place that I still long to be, the Masai Mara reserve in Kenya. I hung it in the bathroom of our house in the South of France, which was called le Kilimanjaro. When we swapped the house in the South of France for a home in Berlin, the picture came with us, and was this time hung in a bathroom that I had decorated with special wallpaper in its honor. It has since been joined by other giraffes, some of them lucky finds, and others gifts. At the end of the row is a painting by a child from a Nairobi slum. Every morning and evening, my giraffes remind me how it feels to be content. In its own calm, modest way, a bathroom can itself be a place that I long to return to.

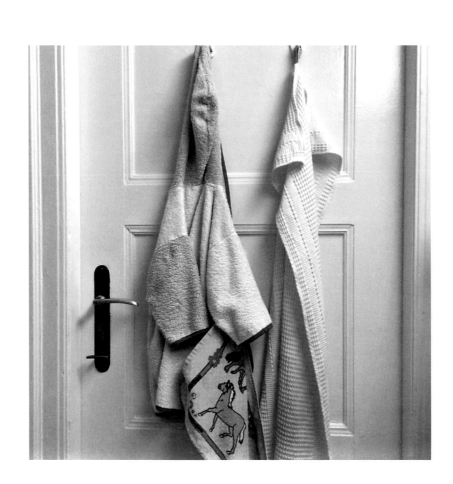

STEFANIE LEIMSNER

Munich

My daughter Juliane, who is six, only sees the point of washing her hands if she's allowed to use her horse towel to dry them. The white towel was handed down by my grandmother Annemarie, who passed away last year at the age of ninety-three. I think of her every time I dry my hands.

JACKY COLLISS HARVEY

London

This oddly shaped cabinet (why are bathroom cabinets always so long and thin?) is the first piece of furniture I bought when I moved into my flat, which is the first home I have ever owned on my own. And being so insanely long and thin, it fit perfectly into the narrow space behind the bathroom door, which I took as a good omen. It's some-assembly-required—I love do-it-yourself furniture.

Whenever I find myself in someone else's home for the first time I always do that awful thing of checking out their bathroom cabinet. Their bookshelves and their bathroom cabinet. Then you know them.

This one's a geological look through my life. On top, some of the shells came from my honeymoon. The shelf below, with the ridiculous grab-bag of hotel freebies, is what you end up with after a decade of sales conferences and book fairs. The tubes and bottles eventually migrate to the travel bag on the door and their journeys begin again.

The shelf under that is where Answers to All Cosmetic Dilemmas go to die, because I'm a sucker for makeup, and it's kinder than abandoning them on the street. The shelf under that with the scents is my favorite. The one under that is aspirational—I long to have beautiful, manicured hands and perfect fingernails, but the only time my hands are presentable is when I'm in New York, where my partner lives. He's also where all the most special of the scents come from. I'd sooner leave the flat without panties than without a spritz of perfume. If it's one he's given me, it's like he's blowing me a kiss.

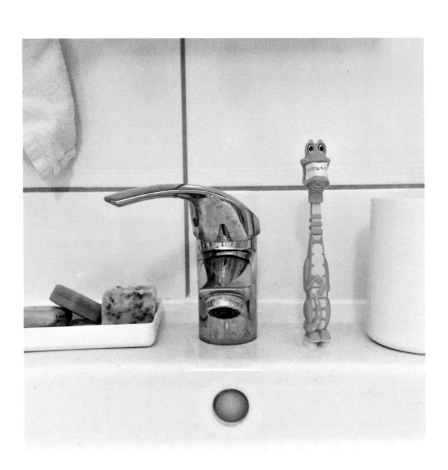

JESSICA AIMUFUA

Berlin

I like the contrast between the prettily arranged hand soaps on one side of my sink and the grinning plastic crocodile on the other. Every day it reminds me to take life, not to mention myself, a little less seriously, and approach it like my child does.

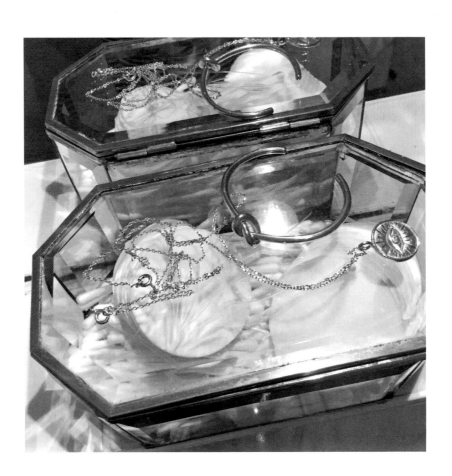

ANNA KATHARINA BENDER

Berlin

For as long as I can remember, my family has spent their summer vacations in Brittany. These include regular visits to the *marché aux puces* and zealous rummaging in the local *brocantes*. Every year we bring back newly acquired bygone treasures, such as paintings, vases, giant lamps, and other such finds. My mother no longer dares to buy anything for me without consulting me first, as our tastes are completely different. But there was this one time, a few years ago, when she felt quite certain that she'd got it right—and indeed she had. This crystal casket has been a fixture in my bathroom ever since and brings a little French holiday air to my life. My favorite jewelry, which I wear every day, lies on top of it.

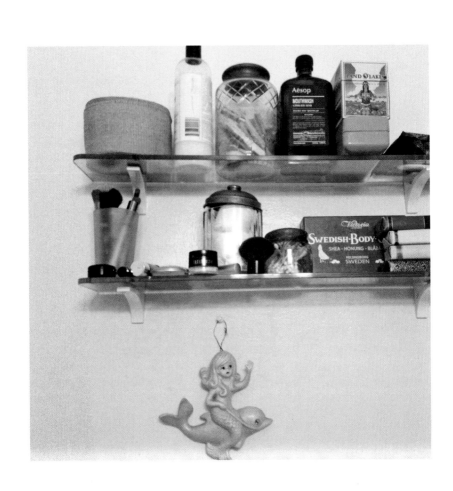

SADIE STEIN

New York City

The little mermaid I picked up from a curb in Brooklyn. On the top shelf: the little basket holds Tampax. My mother had picked it up at a tag sale, and I took it home with me during one of my scavenging trips because I liked the size. The bottle is detergent scented with Le Labo Santal, very luxurious, which I use to wash my lingerie. Clothespins also for laundry; jar from a thrift store. The Aesop mouthwash is a special edition they made when Lydia Davis received a prize from the *Paris Review*; there is an entire tiny short story printed on the label. The Land O'Lakes recipe file (from my parents' old house) is for first aid: Band-Aids, Neosporin, burn cream, etc. I also have a first-aid box in the kitchen because I am very accident-prone.

On the lower shelf: my makeup, such as it is—I'm very bad at hair and makeup both. The Swedish egg soap is for baths (you can get it at Apthorp, one of the independent pharmacies in the neighborhood) and the stacked soaps are from Lisbon and too beautiful to ever use.

DIMITRA ZAVAKOU

Berlin

I keep a few things in my bathroom that have emotional value: a special gift, with handmade crochet details made by my best friend's grandmother and stitched on the towel. The grandmother lives in a tiny village on the Greek island Lefkada. Then, there are golden earrings from my mother, and also mouthwash, toothpaste, salt spray for my hair, the complete lyrics book by Nick Cave, David Bowie's *Little Black Songbook*, and a friendship bracelet from Tinos Island, where I often spend the summer.

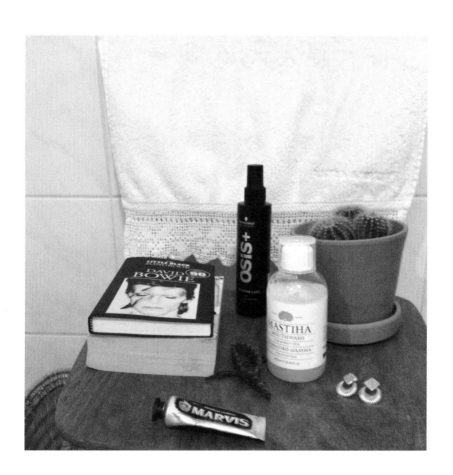

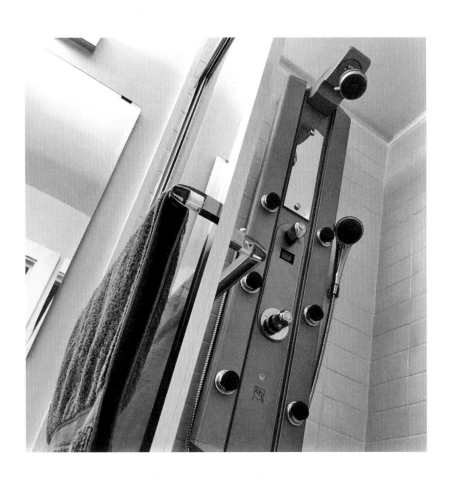

LILY BRETT

New York City

I am unabashedly attached to my new shower. I don't usually have an attachment to material possessions. My attachments are mostly to people. I don't mind if anyone breaks one of my glasses or dishes or vases or scratches a surface.

I am also happy to share almost everything I have. Except for my new shower. I have, so far, managed to avoid letting anyone else use it. Luckily, we have two bathrooms. I didn't choose the shower. The contractor who renovated the apartment did. My request was for a shower. And I got one.

This shower is not an ordinary shower. It can do things other showers can't. It has a shower massage panel with a digital thermometer, six adjustable spray massage jets, an adjustable multifunctional shower head, a hand shower with a sixty-inch chrome-plated brass hose, and a fog-free mirror. You can see why I am thrilled. Although I could give the fog-free mirror a miss. I am not prone to looking at myself, unclothed, in a mirror.

The contractor set the shower at a perfect temperature. Now, I happily shower with water that is never too hot or too cold. And feel full of admiration for what this shower can do. I do nothing other than turn on the water and shower. I am way too nervous to touch any of the settings.

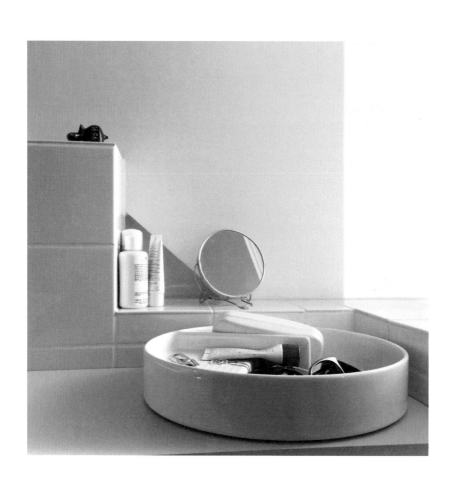

AYZIT BOSTAN

Munich

I am a minimalist, including when it comes to my bathroom. I live on the fifth floor and see the sky and clouds whenever I look out. I also hear the birds, which are twittering loudly at the moment. The bathroom is a place of retreat for me; I love spending time in there. It doesn't take much—the main thing is that it has to be warm and clean. There's only one small detail: in the top left of the photo you can see a tiny hippo, which my boyfriend brought back for me from an amazing trip to Tanzania.

VICTORIA ELIASDÓTTIR

Berlin

Where else do I have a quiet time for some inspiration, I ask myself!

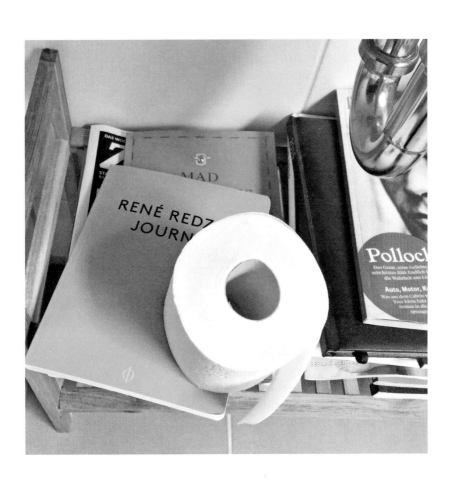

MILENA KALOJANOV

Berlin

The loveliest and most thrilling time of the year is the four weeks between late spring and early summer—in other words, the month of May. We get to soak up the first rays of sunshine, blossoms flutter everywhere, and there's a sense of mounting excitement over the coming summer. The last vestiges of wintry gloom and doom are dispelled by the scent of my constant May companions: Greek sunscreen, which finally gets put to use again—I apply it every day after brushing my teeth—and an ever-fresh supply of lilies of the valley, reflected in my bathroom mirror. The portrait of a woman by the artist Anne Collier dates from an emotional time in my life and reminds me of an exhibition at the Galerie Neu that I saw with my friend F.

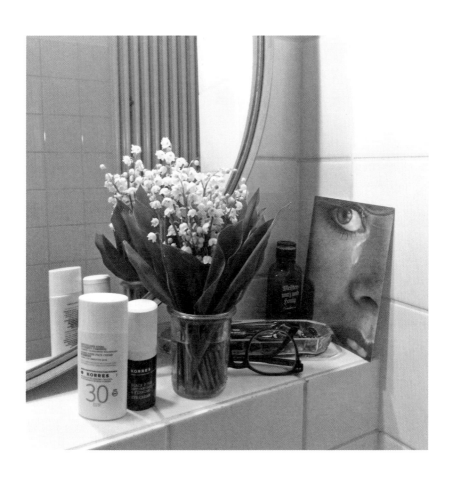

JULIA WERTZ

Berkeley, California

This is my toilet shelf of dubious natural cures for minor (and possibly psychosomatic) ailments. Supposedly, honey is has antimicrobial and anti-inflammatory properties; lavender essential oil calms the nerves; Epsom salt boosts magnesium and helps heal sore muscles and wounds; sweet almond oil is moisturizing; and the botanic milk soak is soothing. But I cannot verify any of those claims, and the botanic milk soak has a bunch of annoying dried flower petals in it that clog the drain. I use these things knowing full well they might be bullshit, but it's a cheap and easy way to indulge in luxury without having to leave the house. So I might be a sucker, but at least I'm aware of it. And I smell good.

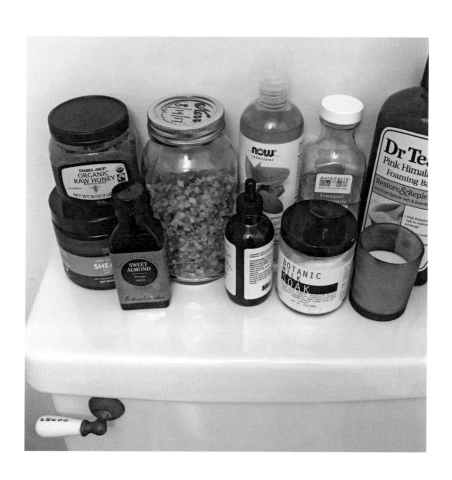

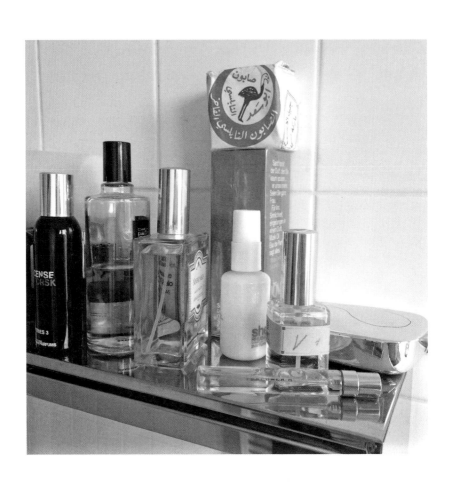

ANNE WAAK

Berlin

I think my first perfume was Sun by Jil Sander, followed by CK One (it *was* the 1990s, after all!). Since then, I've only really gone for fragrances that can be worn by men and women alike. My bathroom has lots of opened bottles languishing on the shelf, as I change perfumes every year or two. I don't mean to do it, but it seems to just happen when I come across a new and better fragrance. In retrospect, older scents are so closely associated with particular periods of my life that there's no going back. Onward and upward! I imagine myself at seventy, sniffing at the old bottles (or using some sort of olfactory device that hasn't yet been invented) and thinking back on everything: the good times, the people who were dear to me, the bizarre fashions. The soap also evokes this kind of memory, as it comes from a particular trip I made. I have a passion for the Middle East that's difficult to put into words. The only thing that I'm not keen on there is the sweet, heavy perfumes. I've now started learning Arabic—something that I tell people far too often in order to explain away my meager abilities. The musk oil in the orange packaging is a joke—it's only there because of its ridiculous blurb: "The skin vibrates with anticipation. Be the ultimate woman. Do it for him."

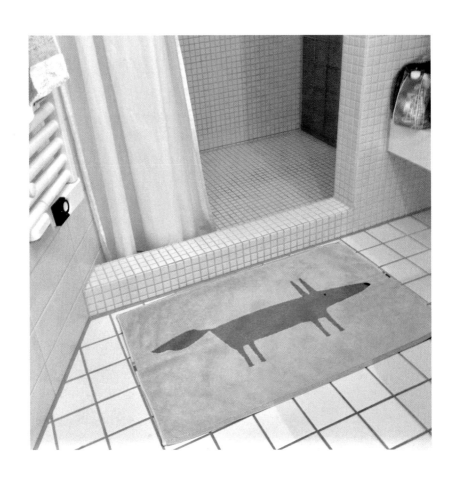

SUSANNE KIPPENBERGER

Berlin

I discovered Mr. Fox in the land of fox hunting, at my favorite department store, John Lewis in Sloane Square, London. It reminds me of a great trip a few years ago, back when the UK was still part of Europe.

MARGO JEFFERSON

New York City

A favorite fetish I bought at a black dolls fair years ago, and the little tin soldier ornament a beloved aunt gave me one Christmas.

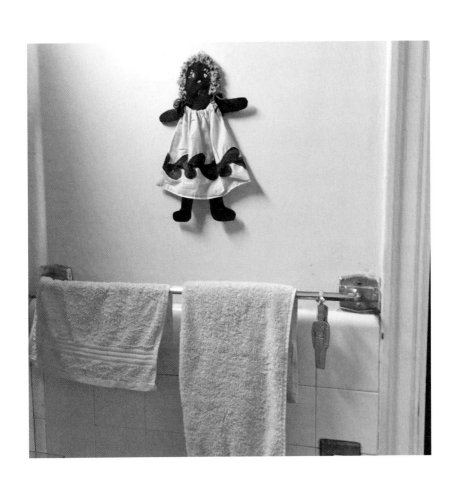

SARAH ILLENBERGER

Berlin

A fossil that I bought from a Moroccan street vendor and turned into a soap dish. My Touche Éclat highlighter, which is supposed to conceal my ever-growing dark circles, the object of my despair. A tortoiseshell hairbrush, along with a turquoise beaded bracelet from my mother, who runs a jewelry store in Munich. In the blurred foreground, my favorite toothbrush.

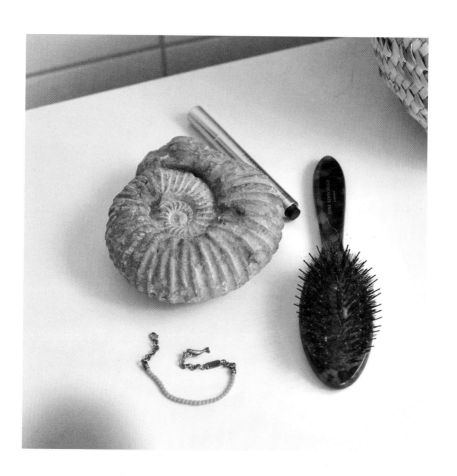

THERESIA ENZENSBERGER

Berlin

This is a compact that I stole from my mother. I've never used it and never will, but I cart it along with me every time I move because the box is so redolent of old-world glamour, and you can never have enough of that in your bathroom.

HEIDI JULAVITS

New York City

It seems wasteful to use a disposable cotton pad only once. I use each pad like four times before I throw it out, and store it on top of my toner bottle in the meantime. I keep the pads in a Dutch sugar tin, which I'm only now realizing is a bit of a mixed message with the teeth cleaning propaganda poster (I have kids). Sleeping pills and a hair elastic and skin cleanser are the bulk of what I need to survive.

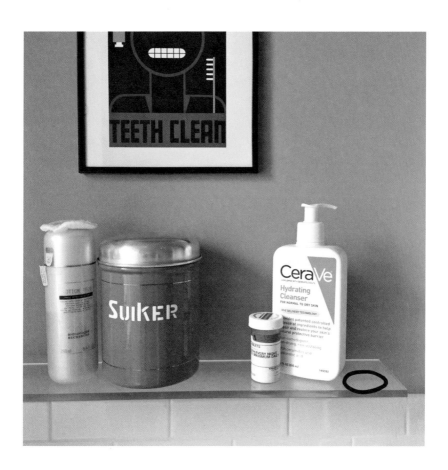

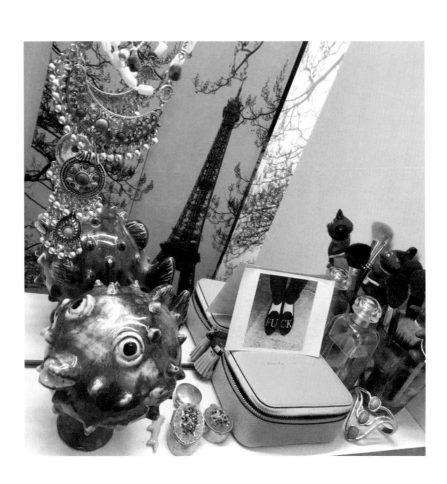

ANIKA DECKER

Berlin

Welcome to my bathroom shelf! On the far left of the picture is a shocked fish, who has darted away in horror at reading the word *fuck*. The shoes bearing the expletive in question were the first outfit suggested by the costume designer on my last motion picture: I was the screenwriter for movies such as *Rabbit without Ears* and the director and screenwriter of *Traumfrauen* and *High Society*. Of course, I never have need of the thousands of makeup brushes clustered on the right-hand side of the photo, because I always look absolutely stunning. I'm particularly proud of the little plastic Menehune man in the glass. I was given him after downing eight highly potent alcoholic drinks at the Trader Vic's restaurant in Munich. The green bottle of perfume to its left was a birthday present from Iris Berben, my favorite actress. The yellow jewel case right next to it bears the famous movie quote by comedy legend Billy Wilder: "Nobody's perfect." That's exactly what I think every morning when I look in the mirror.

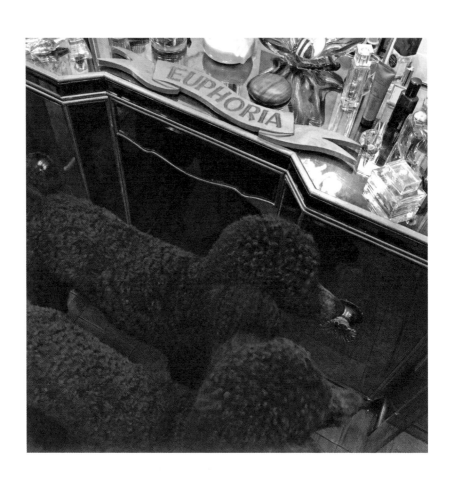

ERICA JONG

New York City

We all know that poodles love powder rooms. They love to fluff up their hair, brush their ears, put on a little mascara. Colette and Simone are very girly poodles. It's hard to keep them away from mirrors.

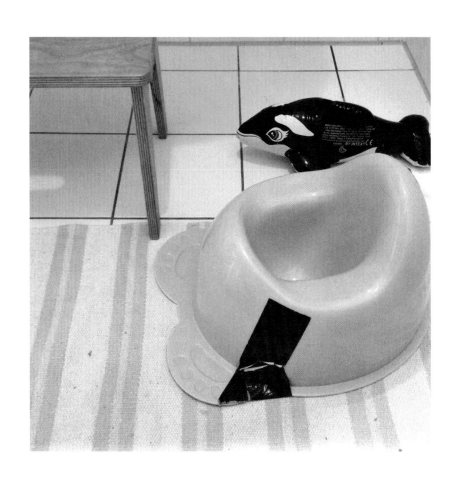

VANESSA FUENTES

Frankfurt

Real life, courtesy of our bathroom: *plastique océanique*, otherwise known as a patched-up potty chair and an inflatable whale that's escaped from the bath.

NICOLE HOGERZEIL

Berlin

I'm a big fan of the architect and designer Charlotte Perriand, who made this stool. I bought it from my great friend Sylvester, who also fitted out my store in Berlin. Everything he chooses is absolutely flawless. The stool is there so that I can drop things onto it instead of throwing them on the floor. In the bathroom, you tend to just drop everything. I don't think I'm the kind of person who likes to linger too long in there. If I'm having a shower, I might be in there a little longer, but otherwise I'm hardly in my bathroom at all, despite the stool.

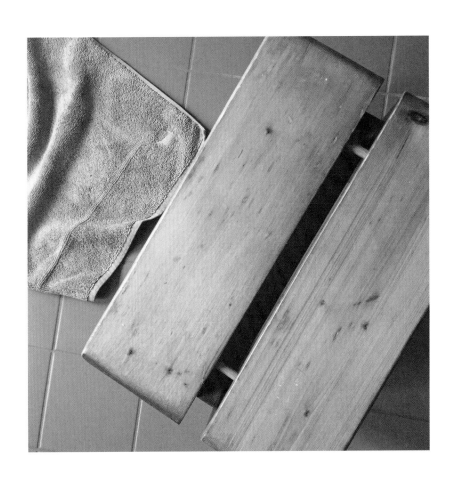

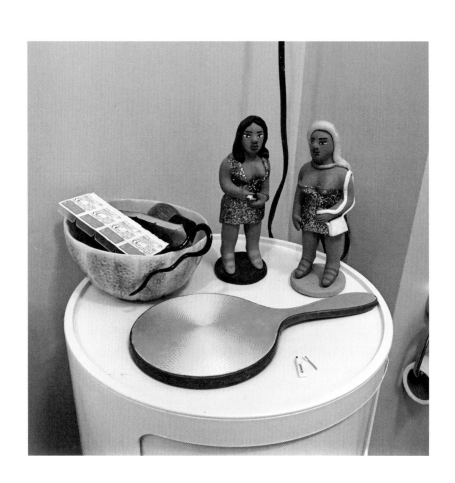

JOANA AVILLEZ

New York City

The cantaloupe bowl originally belonged to my Portuguese grand-mother, one of a set of ten, and it is supposed to be filled with gazpacho—not odds and ends. The gold hand mirror belonged to my French grand-mother; I remember it always on her vanity in her bedroom. When she was busy, I would walk into her room and pick it up, feeling like I could be caught at any minute—oddly it still incites that same furtive reverence in me. The two ceramic figurines are from Mexico, a gift to my mom from my godmother, her best friend. Supposedly, they're prostitutes. I love everything about them, how one is smoking, and how they seem to truly be talking to each other. Everything here belonged to someone else at one point and is connected to my family, except for the miniature toothbrush and toothpaste, which I bought at a dollhouse supply store in Yorkville, New York.

SABINE HAVERKÄMPER

Berlin

Our bathroom is small and cozy. It has a shelf with all sorts of things on it—bottles, creams, toothbrushes, rosewater, and bath toys. In the middle of it all stands a small framed photograph of my father, who died when he was still very young. It must have been taken in the early 1970s. He and my mother got in their Citroën 2CV, dubbed the Green Duck, and motored down to the Costa Brava, which was still completely unspoiled at that time. She told me that they stayed with a Mr. Pepe and had a wonderful time. To my eyes, that picture embodies the power of the water, and I like it because it captures the moment at which my father must have just come out of the sea, turning toward the camera in surprise. When I get out of the shower, I often look at it and think of him.

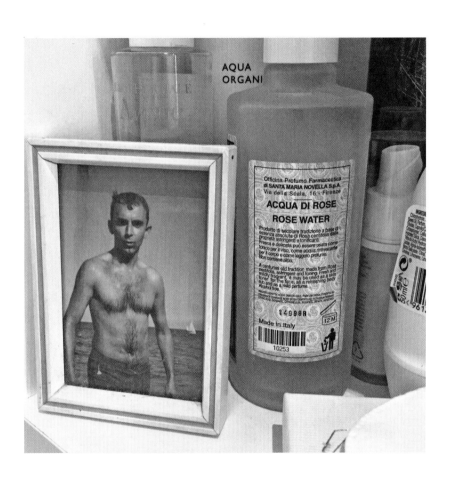

MELANIE DAL CANTON

Berlin

My daughter, Loviz, loves having a bath. She likes pretending to be a "big fish" and stages flooding scenarios in our bathroom. A recurring character, at least when it comes to being a flood victim, is this little Playmobil man, which she inherited from her older brother, Levi. After one of her evening baths, we let the water out of the bathtub and the man got swept directly into the outflow by the slipstream of the draining water and was left hanging there. Loviz and I laughed, and I thought how lovely it was to pause for a moment and simply share this moment with her.

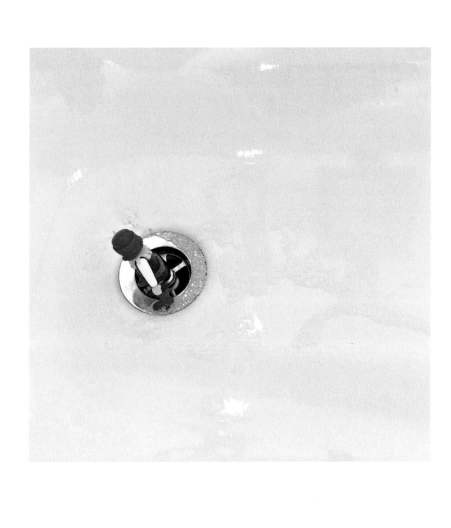

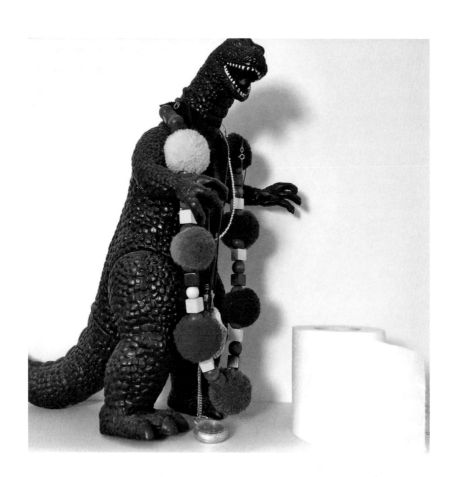

MARA HELLMANN

Berlin

I made this necklace back in the 1980s, sitting in bed with my mother and elder brother. My mother wore it with her dyed blond hair and striped leggings. I bought the Godzilla for my little brother at the flea market, on a slow day. He has stood on top of the mirrored cabinet in our bathroom ever since. He just about squeezes in under the ceiling. The pocket watch has my initials engraved on it. It was handed down to me by my mother, who has the same initials. That and the ring on my finger are the only jewelry that I own.

RIKKE GERTSEN CONSTEIN

Copenhagen/Berlin

My photo is divided in two. On the lower half, you see my bathroom in Copenhagen, where I live during the week; it is just very functional. On the upper half, there's my bathroom in Berlin, where I spend my weekends with my love, a lot of warmth, our friends, and nice smells.

SIMONE BUCHHOLZ

Hamburg

A few years ago, I went through a burlesque phase. A friend of mine dragged me along on a weekend away—two days, ten women, alcohol, and nonstop dancing. We learned how to undress to loud music without taking everything off, and to drive spectators wild in the process. My friend was less than enthused but I was thrilled, because in that dark corner of the nightclub where we danced for each other, I rediscovered something: the woman that I must have been before the birth of my son. A wild, untamed creature. That woman had somehow gone AWOL in the early throes of motherhood. My gold high heels had been relegated to the very back of the closet, and those days I mostly wore flat boots to facilitate fast walking. After the burlesque weekend, I retrieved my golden beauties from their resting place with furtive tears in my eyes. I continued to go on the weekends: every few months I'd give myself forty-eight hours as an irresistible pinup girl. (You learn the art of bending over in a manner that is at once highly arousing and incredibly powerful.) After the third such weekend, Koko la Douce, the boss of the whole outfit, presented me with a pair of red pasties. When I got home, I showed them to my husband and our four-year-old. They ignored me and continued on with their roughhousing. *Oh well,* I thought, *it's more my sort of thing.* After about a year I had done enough burlesque courses. At this point I was wearing too-tight skirts without hesitation, and plenty of over-the-top creations stood alongside the more utilitarian footwear on my shoe rack. The glittering pasties remain in my bathroom as a kind of reminder not to lose sight of myself. Don't let yourself be buried under the weight of all your tasks and responsibilities. Make yourself heard, and don't be afraid to wiggle a bit while you're at it. And keep your pasties warm.

KAORI KUNIYASU

Berlin

This little jellyfish is my good-luck charm. I found it at Sea Life in Berlin. I went there with my son on the occasion of his first birthday. It was my first time in an aquarium. The jellyfish now hangs in our little bathroom and gives me a feeling of peace and serenity.

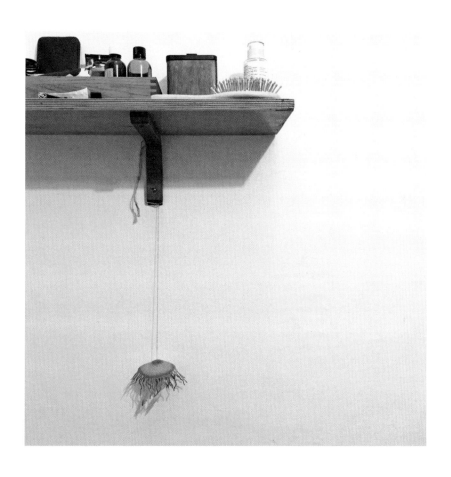

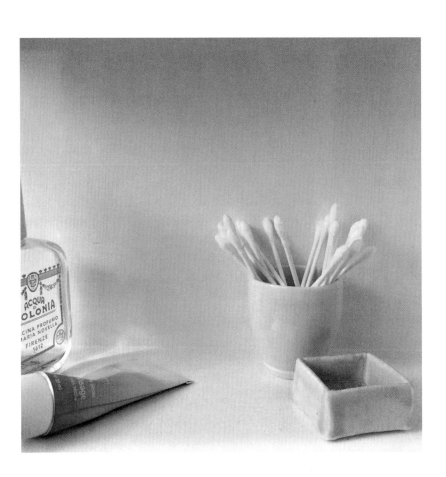

EMILY HASS

New York City

Potpourri is my favorite scent by Santa Maria Novella. I was so happy when they opened on Lafayette Street here in New York.

The red Weleda lotion: German cosmetics are my favorite, and I always stock up when I'm in Berlin.

I travel there every year for my artwork—for the last ten years I've used the Berliner Landesarchiv to locate the architectural records of persecuted Jews, artists, and intellectuals in the 1930s as the source material for my gouache works on paper. And more recently to interview Syrian refugees about the homes they have fled to come to Berlin.

Q-tips in tiny beaker: made by my mother, a potter. She was born in London and moved to America in the 1960s with my father and my two older sisters. She has her studio on Martha's Vineyard, where she lives with my father. Every plate, cup, and bowl we used as a family growing up was made by her, and I continue that tradition today. The green square dish was also made by my mother; I use it for rings, earrings, and little shells.

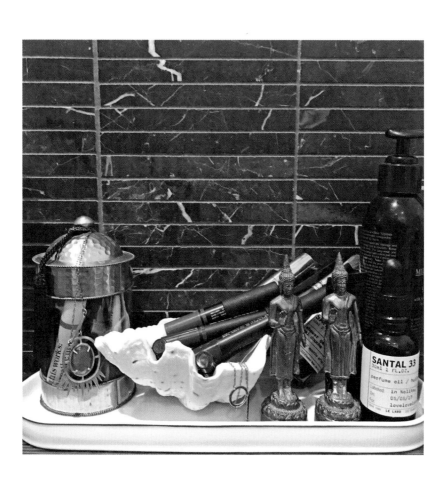

ANNA ROSA THOMAE

Berlin

The world out there is a circus, a vast arena hosting a never-ending succession of performances, so how does that filter its way into my thirty-square-foot bathroom? For one thing, there's the mask that allows me to concentrate my powers and prepare to slip into my next role. Every morning I wash my face with cold water, and the glass of wine or two that I drank the night before, the beads of sweat, and a night of restless sleep fall away in an instant. A lineup of creams, makeup, and perfumes stand beside the round sink, just waiting to get me ready for my next performance. I use one magic potion to dab away my laughter lines, and another to paint my lips red. Next to the bottles are two well-traveled Buddha figures, souvenirs that my brother brought back from Thailand. They remind me to maintain my inner calm and encourage me to start my day with serenity. My bathroom is a veritable chamber of wonders, but sometimes I think that just a bathtub would suffice.

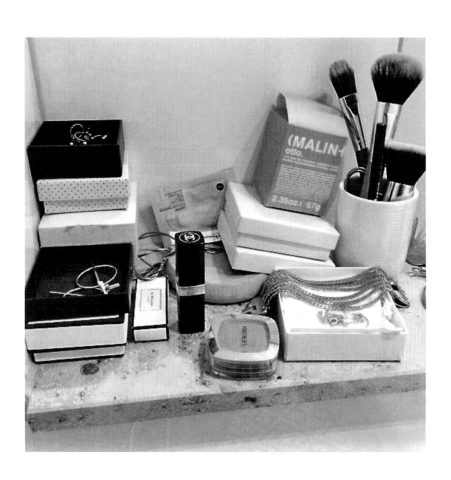

NICOLE ZEPTER

Hamburg

I have two bathrooms. One is big, with a bathtub and shower, several rugs, and a giant mirror. It is almost always tidy and constantly under siege, especially by my son. Then there's the smaller bathroom, the girls' bathroom, my bathroom. Nothing's ever tidy in here, with makeup and scented candles in tottering piles.

CAROLIN WÜRFEL

Berlin

I have a new ritual. When I'm in Berlin and not traveling, I have a bath late on Friday mornings, simply because I can. It's an unconventional, almost unfeasible time of day, but that's what makes it so brilliant. The water shouldn't be so hot that there's steam rising from it, but just pleasantly warm. Just like the small, narrow room itself. There are no candles, just steam-clouded daylight, seeping laboriously in through the slit of a window. No music. Just the sounds of water and my body moving around.

Like the rest of my apartment, my bathroom is a space in progress. Small objects like vases or bowls appear and are whisked away again, while the shower curtain is constantly being swapped for a new one: pale blue to multicolored plaid, and then back to plain old white. For years a naked bulb has dangled from the ceiling, suspended on a thin black cable, just waiting to be paired with an exquisite ceiling lamp, which has, however, remained elusive. The walls have recently been painted pink, and I have no intention of changing them. The same goes for the swallow. It reminds me of a little hut on the beach in Tulum and the days that we spent there after saying "I do" to one another. Between the sea and the jungle, the swooshing and the chattering. Ultimately, the natural world always outdid us for noise. Every night we lay under the mosquito net in our round little mud hut with the pink walls, and I was convinced that I would be swept up by a mighty wave at any second. I felt so small, but I was where I was meant to be. Everything was well with the world. And sometimes I get exactly the same feeling on these newly discovered late Friday mornings.

KATHARINA WYSS

Berlin

On the walls of my bathroom hang things that connect me to my family. There are two photos from a trip that I made to Rome in honor of my grandmother, using money that I inherited from her. I chose Rome because my favorite photo of her—looking like an Italian movie star—was taken there. There's the dome of St. Peter's, because when I was a child I saw a white dove in there and was convinced that the Holy Ghost had deigned to appear to me. Then there's my great-grandmother's "teardrop necklace." Family lore has it that anyone who wears it is bound to start crying. Having looked into its past, it transpires that my great-grandmother was wearing it when her son fell to his death in the mountains. So it's there to be worn if I ever feel that I really need to have a cry. You can also see a Luke Skywalker clock in the photo. The inner surface conceals a hologram of the *Death Star*. I'm a director, and this was my lucky charm for the motion picture that I've just finished making.

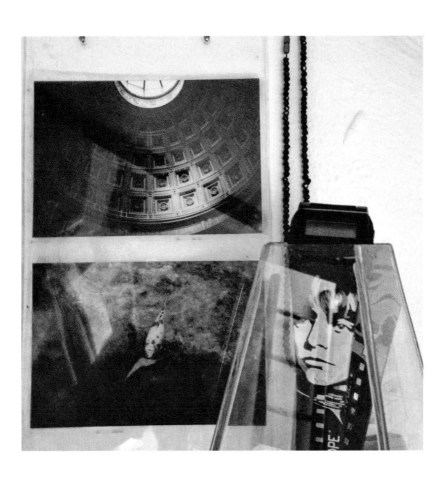

MARGAUX WILLIAMSON

Toronto

I love this window. It's weird next to an open shower to have cracks and unfinished wood, and probably not good, but it makes you feel like it's outside. I always open the window when I shower, even when it's snowing.

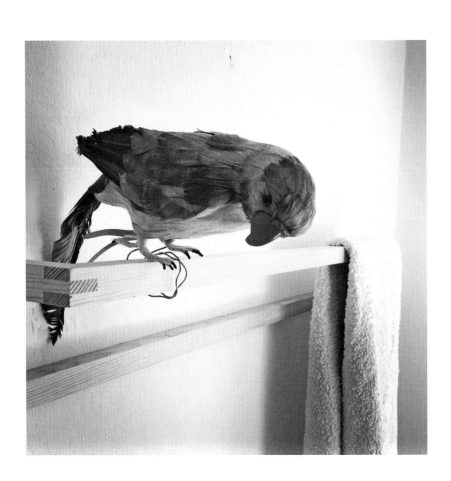

LINA MUZUR

Berlin

Unfortunately, Udo, the bird, doesn't talk. But I think that he's quite happy to be in my bathroom nonetheless. He loves to sit on the towel bar and bask in the sunshine, while I admire his colorful plumage.

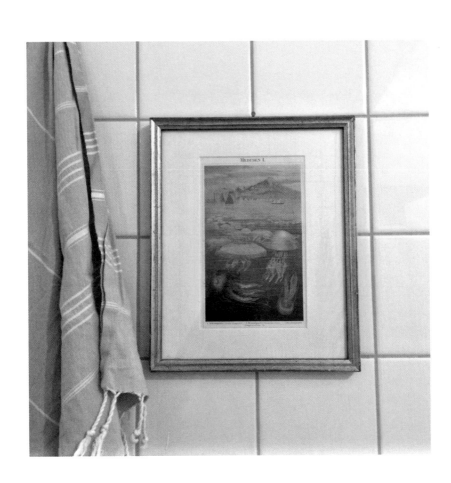

SHOU AZIZ

Berlin

This jellyfish picture hangs over my bathtub. I bought it at a flea market last summer with my boyfriend and found that it looks best in the bathroom. I've always considered the bathtub to be a place for dreaming. The hazy warmth of a hot bath allows me to really immerse myself in my thoughts, which come and go seemingly at random, just like the jellyfish.

DIANA CHEN

Paris

My bathroom is the only room with a door in my apartment, so it's somewhat sacred to me.

The walls are painted dusty blue, a Massimo Vitali calendar hangs on one side, and on another, a piece of Brigitte Bardot's face made by my friend Lily in Montreal out of pipe cleaners. I have a beautiful dark wood counter lit from above with a row of six light bulbs like in a backstage dressing room. Sometimes the yucca takes its shower in the tub when it's hot out.

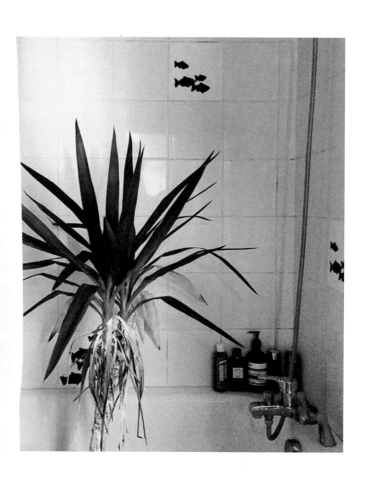

NINA BUSSMANN

Berlin

A girlfriend once came to stay with me and was much taken with the odds and ends in my bathroom. But, despite her admiration, she made it clear that she would never have left her tampons lying around for all to see. She stressed that this wasn't meant as a criticism; she simply would have found it embarrassing. We talked about it a bit more, and I ended up feeling embarrassed, too. Later on, I told others about it, and most of them were shocked, so I remained embarrassed. I was given the Schleich donkey for Christmas, and bought the postcard from a university library. On the back is the caption "Fleeing zebras."

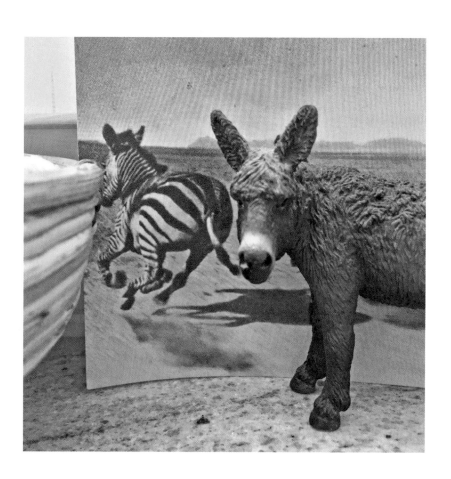

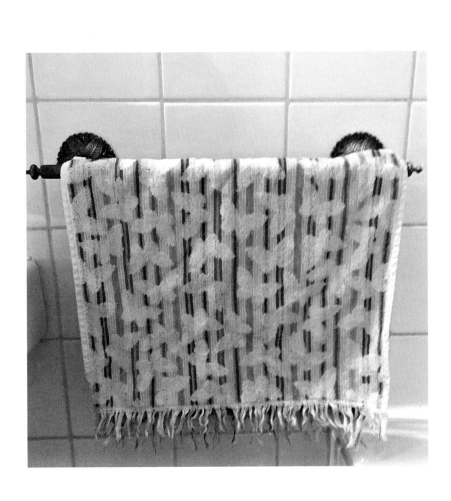

SUSANNE STEHLE

Munich

On a trip to Milan I fell in love with this little butterfly towel. Unfortunately, it's completely useless, as it's so small that it gets completely soaked just from drying one hand, and then takes ages to dry out. But it has stubbornly kept its place on the only real towel bar in my little bathroom, and it makes me happy every day.

FRAUKE GEMBALIES

Berlin/Paris

My bathroom is a place of languor and relaxation. Above all, it provides me with enough space to find serenity. On the wall hangs *Schockdusche* by Burkhard von Harder, a photographer and filmmaker. Of course, the bathroom is also where I keep my staples, the products that I never travel without: hand cream, concealer, and my favorite scent in a Hermès porcelain bowl, a present from a dear friend.

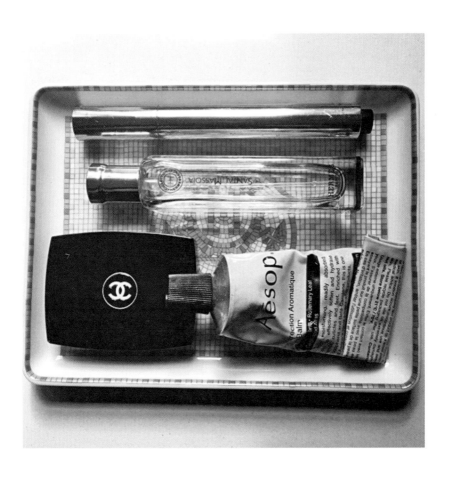

ISABELLA POTÌ

Lecce, Italy

My mother bought me the red bathrobe more than five years ago from a market.

And then there's Kira, who has been with me for two years. She really loves my bathroom, but only when I'm in it. She always follows me in or waits next to the door until I come out. She's a German shepherd with a sentimental Italian heart.

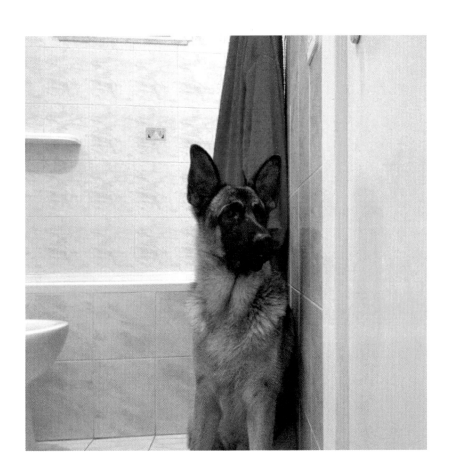

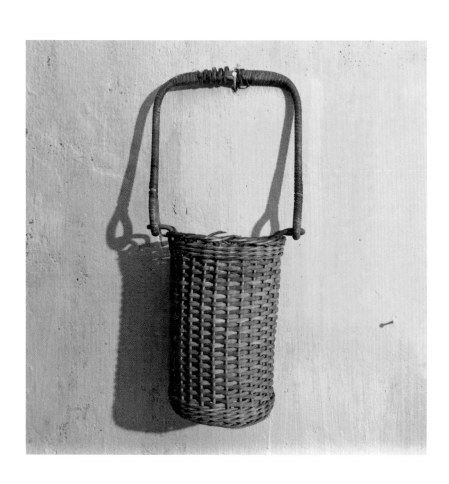

ANNE SCHWALBE

Berlin

This is a basket that I use to store clothespins. For a number of years, it hung in my father's summer house. The basket originally belonged to my mother, who also kept clothespins in it. Now it hangs in the kitchen-cum-bathroom of my old country cottage. The cottage doesn't have a proper bathroom; in fact, the shower is outside, beside the apple tree. Taking a cold shower out there is really refreshing and never fails to make me happy, even in winter.

KERA TILL

Munich

The gloves are a simple cotton pair from the drugstore. You can wear them overnight after slathering cream all over your hands. I do this sometimes, but I use them for all sorts of other things, too, like when I'm unpacking something and am going to be handling a lot of paper, or if I've just had a manicure and want to make sure my nails don't get chipped. I particularly like the color and the fact that I can wash them in the machine.

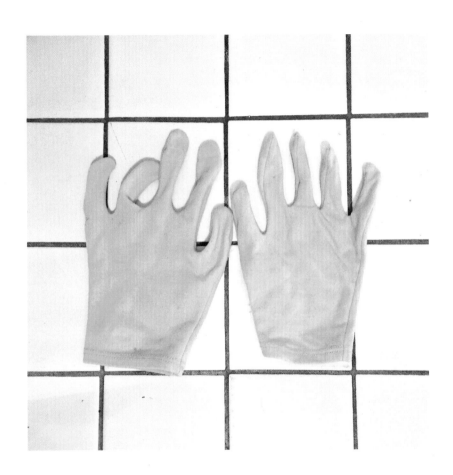

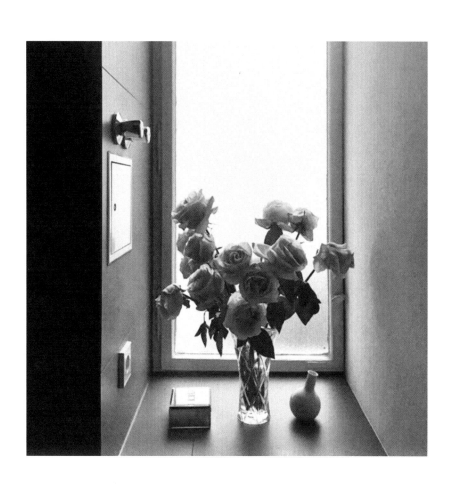

VERONIKA HEILBRUNNER

Berlin

The picture was taken during our office Christmas party, which was held at my place as a way of keeping it an intimate affair. I loved the way Ruby, who arranged the flowers for my whole house, including the bathroom, used the most beautiful roses. The crystal vase is from KaDeWe, a store in Berlin, while the little vase to the right is from KPM, a porcelain brand. The mirrored box was a gift from a close friend.

ANNE PHILIPPI

Los Angeles

This picture, which I tore out of *Psychology Today*, has accompanied me for years, and I always hang it up in my bathroom. The body, the bra, and indeed everything about that blond bombshell, not to mention the tiny bunny drawings in the background, are all a daily vision of my idea of femininity. Apart from that, my bathroom is very clean and tidy. The most beautiful bathroom that I've ever seen was in the Mark Hotel in New York: clean, black-and-white tiles and an enormous bathtub. I could spend hours in there; it was better than any living room. I like to imagine the blonde in a bathroom just like that.

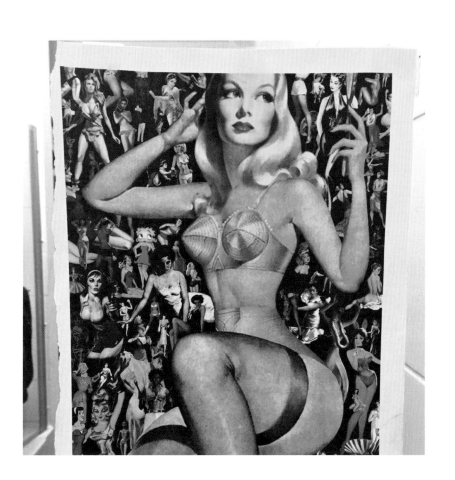

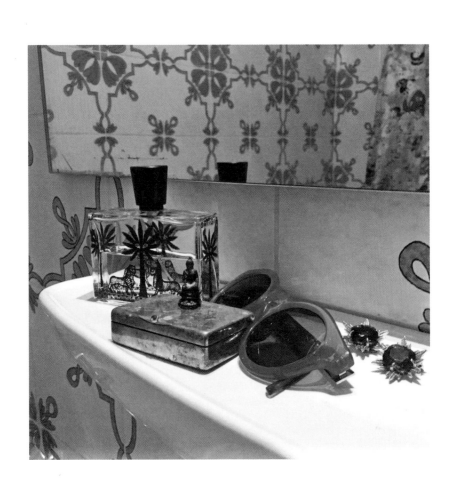

ISABELLE GRAEFF

Berlin

I see my bathroom as a place of routine and thus calm. It's also where I keep mementos to remind me of things. My little Buddha reminds me to meditate: after all, thoughts need to be cleansed and carefully tended. Beside it is a palm-print perfume from Ortiga. I came across it with my mother in the South of France, and now we both wear it. The earrings come from more northerly climes—I discovered them at Portobello Market in London. After painstakingly examining each of the ten thousand pairs of earrings at the stand of a very patient vendor, I suddenly thought, *What I need is a pair of purple stars.* They always look just right, and we've been constant companions ever since.

NICOLE ARAGI

New York City

I used to be a bookseller and am now a literary agent, so my life consists of working with contemporary books; when I was young my uncle gave me a stack of old Penguin editions that he picked up in England (I was living in Lebanon at the time). I read every one of them, understood some, others not at all, but they came to me in those ravenous reading years, so it didn't matter what I did or didn't understand. Some fifty years later I spotted this wallpaper in one of those magazine articles listing "great gifts for book lovers," and it reminded me of the pile of old Penguins that used to sit by my bed. The old books that, in part, led me to the job I now do.

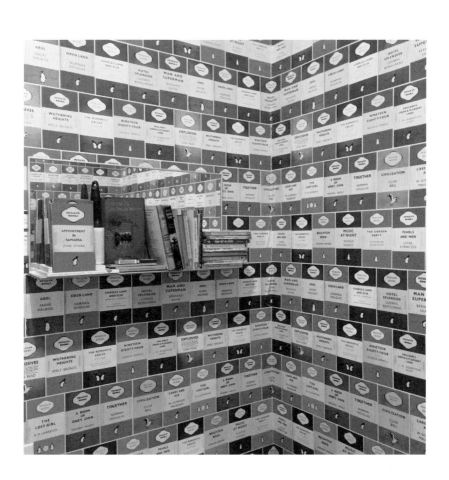

SARAH BUSCHOR

Munich

I love a good still life. No matter whether it's a random juxtaposition or a cryptically crafted arrangement, a still life is always the gateway to a whole host of stories. This was the case in the days of Jan de Heem, Clara Peeters, and Sebastian Stoskopff, whose paintings, replete with nautilus goblets, glassware, and porcelain bowls, first invented the genre and told the story of an emerging trading nation. My little bathroom arrangements have more modest dimensions, of course, but they still have a tale to tell. There's the bangle from Paris, the wooden bowl rooted out in Tokyo, the brush hiding in its pouch, and, surveying it all, David Bowie in the bathroom in Nicolas Roeg's wonderful 1976 sci-fi movie *The Man Who Fell to Earth*. This sums up what a still life actually is: a melancholy snapshot of a moment that has always already passed, however much you might want to hold on to it.

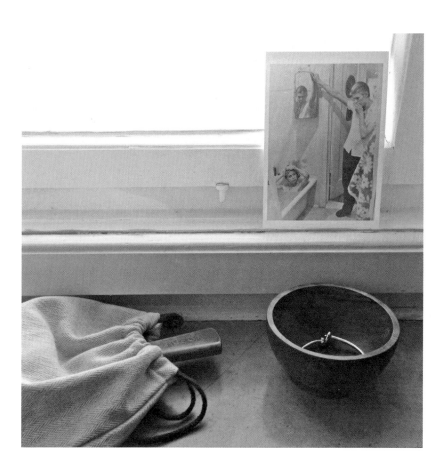

ANNA-LENA JEHLE

Berlin/Munich

I bought the tiki-style mirror in the store-closing sale of an old barber-shop in West Berlin. It didn't go with any of my stuff. Since then I've assembled my own little shrine to the tropics around it—all for the sake of my tiki mirror. Now my bathroom has a real beach hut feel to it.

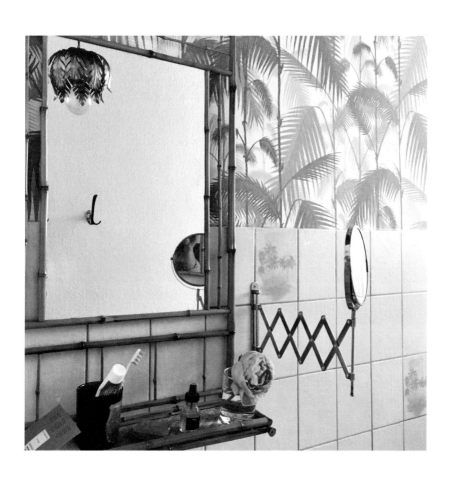

ISABEL PALMER

Tokyo

When we were little, my mother would dab a bit of baby cologne through my and my brother's hair every morning, as is customary in the Philippines. No matter which grown-up perfumes I discovered later in life, my favorite fragrance remains the familiar baby cologne from our childhood. Today I still use it almost every day and dab it into my young son's hair in turn.

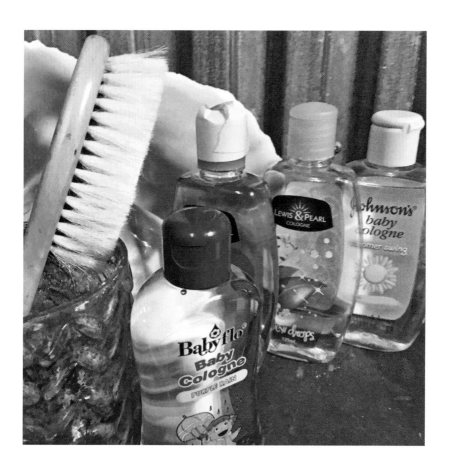

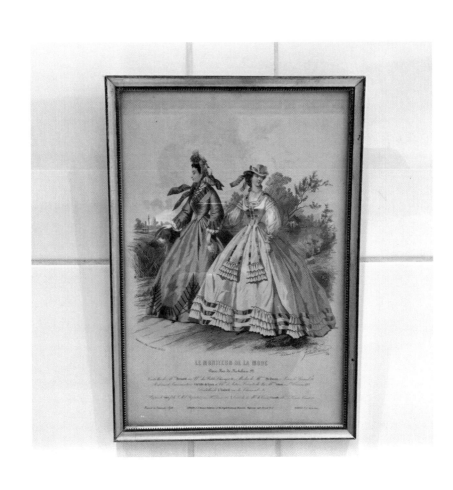

LE MONITEUR DE LA MODE

ORIANE BAUD

Berlin

In winter 2015 I started setting up my new home. Once all of the furniture had arrived, much of the apartment reminded me of my parents' house in Switzerland and my grandparents' home in France. Every item and every piece told its own story. In my bathroom, I have an old golden candlestick, a mirror that goes with it, and lots of old Ladurée macaron boxes that I use to store odds and ends. Plus this old-fashioned sketch. My mother discovered it in a Parisian flea market in the 1970s and framed it herself. I found dozens more drawings of this kind in my grandparents' house. My grandmother had a similar passion for fashion and style. The drawing in my bathroom reminds me of this every day and shows me just what femininity and elegance mean.

JINA KHAYYER

Paris

What you see is what you want to see. Before Christopher Makos's photograph of Andy Warhol ended up in my bathroom, it hung for a long time on the mood board beside my desk, as inspiration for my writing. I make sure that this photograph follows me everywhere so that I don't forget how ridiculous vanity is, or that every judgment is just a matter of opinion.

What I particularly like about this photo is that it is an attempt to capture a moment of vulnerability—someone looking at himself in the mirror after getting washed. Warhol tries to defuse this moment with absurdity. He now hangs directly opposite our bathroom mirror, so that when you look in the mirror he appears to be peering over your shoulder. Granted, it's pretty freaky, but at least it means that I'm startled by Warhol's appearance and not my own.

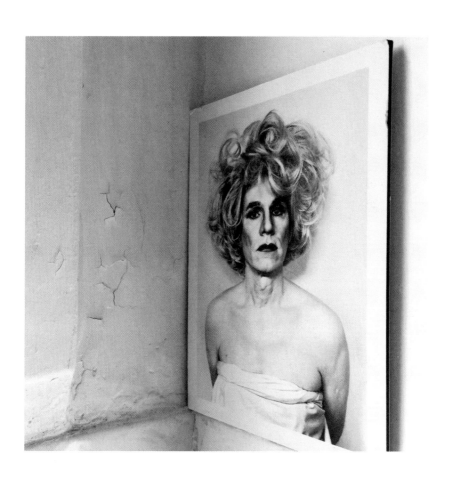

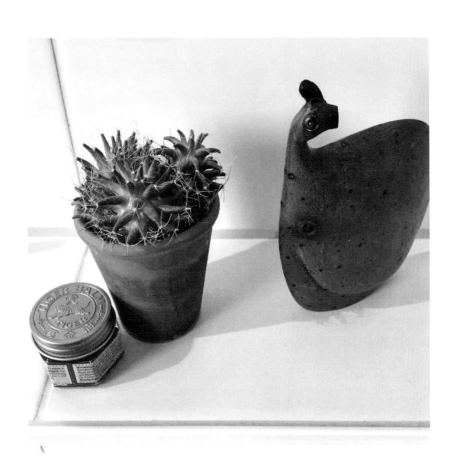

JANIS NACHTIGALL

Berlin

My bathroom is my oasis, a bright, peaceful place with lots of plants, pictures, and other things from all over the world. I love traveling, and I want to be reminded of lovely moments every morning, so that I can take these positive thoughts with me as I go about my day. The photo shows a trio of things from my travels. There's a Zimbabwean bird (although its beak is no more, thanks to a friend's wild little Spanish niece)— a souvenir from a wonderful trip. It sits nicely alongside other exotic additions to the bathroom, such as a banana plant and several cactuses. The tiger balm helps to relieve tension (particularly useful after evening yoga sessions). And the baby cactus is a present from a dear friend and former roommate.

ELISABETH RANK

Berlin

Our days begin and end in the bathroom. It's not the end point, but rather a caesura before sleep arrives. One last look at long toes and scars on knees, a stray hair on one's belly; at tattoos and those blue marks that fade away after a couple of days; at rough elbow skin, a torn fingernail; at eyebrows and hair-ends, the inventory of what the day has done with us, the traces that it has left, what we've managed to rinse away, and what we will take with us to bed and into the night. The next morning, we discover pillow lines on our cheeks, a dent in an eyelid, the edges and traces of everything that's happened to us, giving us a final wave. And then it's time to start again. Time to comb out, wash everything down, set everything straight, while leaving the door open to chance, and remembering to flash a grin—best do it here before you dash out—and to get to grips with yourself, as few others can, and do it carefully, gauging your own contours, not only as a learned skill but as pure touch, getting the measure of yourself, saying, I'll take care of you, you're coming with me, then jolting back into your own body, because there's so much waiting for you out there, because there's always something or someone out there waiting. We get ready, we head out, we take the plunge, and sing at the tops of our voices. No one can hear us in here; here no one can do anything to us at all. That's why we puke in here and cry every now and then, why we kiss and bite each other in here, dress and undress. This is always the crossing point, the interface, the rough edge, the place where we decide what's going to happen to us. The place where nobody sees us.

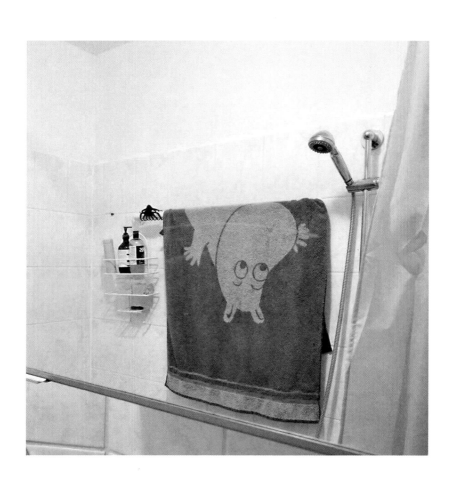

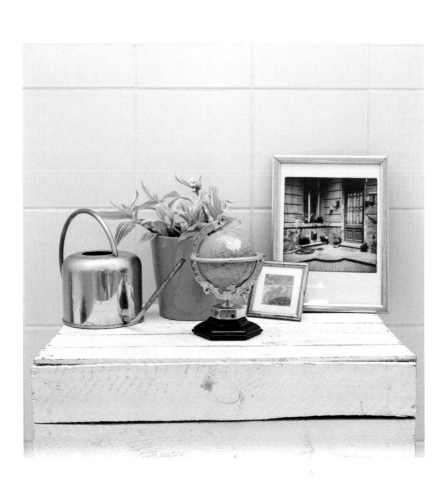

THI-NGOC THAI

Berlin

I love strolling around the flea market on Arkonaplatz on a Sunday, coffee in hand. I unearthed both the watering can and the little picture on one of my wanders there. I discovered the mini globe two years ago at the Dong Xuan Center, a big Vietnamese covered market in Berlin. It's actually a cigarette lighter and was one of the first objects that I bought for my apartment. At some point, I noticed that the globe is upside down, and it gave me a good laugh.

The photographer Joe Dilworth gave me the big black-and-white picture on my thirtieth birthday. It shows a rear courtyard in Budapest in 1989. Receiving this as a gift took my breath away—I love Budapest and its courtyards. Every morning when I go into the bathroom, it either awakes my wanderlust or plunges me into a lovely nostalgic reverie.

LUISE STAUSS

New York City

New York bathrooms are small and rarely have windows. They are tight and tiled and efficient spaces. The size and comfort of this miniature of a room is disproportionate to what it means to me. Only two people fit if one of you is in the bath, and my blue-eyed son talks in the bath. Every night I hear about his adventures that at first did not extend much beyond our apartment building. His stories draw bigger and bigger circles in the city every day. I sit under the boats, listening, and don't want to be anyplace else.

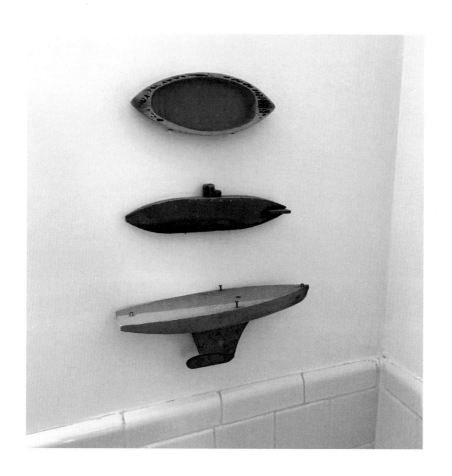

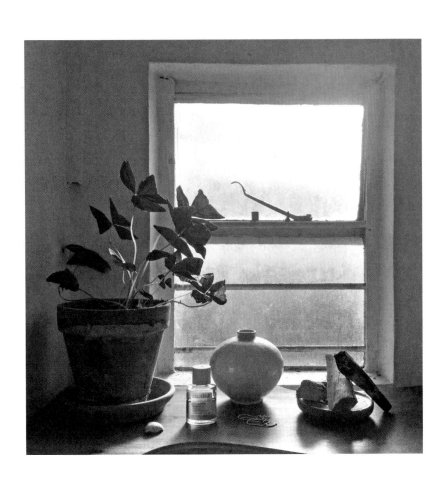

ZSUZSANNA TOTH

London

I've almost been living in England for a few months—in London, to be precise. I say "almost" because it feels like a somewhat foolhardy new beginning. So it's hardly surprising that I've adorned the bathroom of my newfound home mainly with favorite objects from times gone by: here my mother's necklace from Hungary, carrot oil from Germany, and a vase from Austria are all doing their part.

YUJIN LILY SEO

Bangkok

I have collected these objects over many years from many different countries. There are also some of my daughter's drawings. All these things are assembled at the place where we start our day in the morning and represent a strong emotional connection to our past and future.

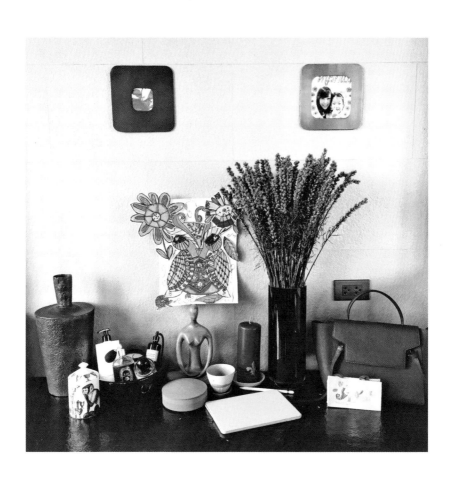

ACKNOWLEDGMENTS

Many thanks to all contributors who sent me their bathroom photos and stories. Thanks, too, to those who sent contributions that we could not include in the book for reasons of space.

I owe a debt of gratitude to Melanie dal Canton, who exhibited the photos in her shop.

Thank you to Petra Eggers, who took a shine to the project right away and saw to it that it could be made into a book.

Thank you to Leanne Shapton for her friendship—and the cover.

I am grateful to Rebecca Casati, editor extraordinaire at Suhrkamp, who made all of this possible.

And thank you to James—with love.

ABOUT THE CONTRIBUTORS

AGNES BARLEY is an artist. She lives and works in New York City. P. 11 • ALEXA KAROLINSKI is a German-Canadian filmmaker and lives in Los Angeles. Her first documentary, *Oma & Bella*, was shown at cinemas worldwide and on television. She has also published a cookbook to go with it. Since 2013 she has produced films for the Eckhaus Latta fashion label. She is currently finishing her second documentary and is writing her first feature film script. P. 27 • ALIZÉE LENOX writes poems, is a post-production specialist, and lives in Berlin. P. 85 • ANA BOTEZATU is an artist and lives and works in Berlin. P. 43 • ANIKA DECKER is a screenwriter and director. Her latest motion pictures, *Traumfrauen* and *High Society*, were screened in cinemas. She lives in Berlin. P. 127 • ANNA WINGER is an American writer living in Berlin. She is the author of novels, essays, and screenplays. She created the TV series *Deutschland 83* and *Deutschland 86*. P. 70 • ANNABELLE HIRSCH is a freelance journalist living in Paris. Her work has appeared in publications including the *Frankfurter Allgemeine Sonntagszeitung, taz, Zeit Online*, and *Harper's Bazaar*. P. 19 • ANNA KATHARINA BENDER studied art history and lives and works in Berlin. She writes the blog ocreblog.com. P. 99 • ANNA-LENA JEHLE works in marketing at BMW. She lives in Munich and Berlin. P. 188 • ANNA ROSA THOMAE has lived and worked in New York, London, and Los Angeles. She runs the company ART Communication + Brand Consultancy and the art venue ART 25 in Berlin, both of which she founded. P. 151 • ANNE PHILLIPPI is a freelance writer who lives in Los Angeles and Berlin. Her novel *Giraffen* was published in 2015. P. 180 • ANNE SCHWALBE is a photographer living in Berlin. Her interests include nature, gardens, and calm. See anneschwalbe.de for more. P. 175 • ANNE WAAK is a freelance journalist and writer living in Berlin. P. 115 • ARIELLE ECKSTUT is the author of ten books including *The Secret Language of Color* and *The Essential Guide to Getting Your Book Published*. She is also the co-founder of LittleMissMatched, a company that sells socks that don't match in packs of threes. She lives in Montclair, New Jersey, with her husband, daughter, and dog. P. 51 • AYZIT BOSTAN is a designer living and working in Munich. P. 107 • BRITTA THIE is an artist. She created the web series *Translantics* and *Superhost*. She also works as an actress and model and lives in Berlin. P. 76 • CAROLIN WÜRFEL writes for *Zeit* magazine and lives in Berlin. P. 154 • CHANTAL RENS is an artist and publisher at Pantofle Books. She lives in Tilburg, Netherlands. P. 41 • CORINNA BARSAN is an editor at Grove/Atlantic and lives in New York City. P. 31 • DENA is a

singer, songwriter, and producer. She works in Berlin, London, and New York. Her first album, *Flash*, came out in 2014, followed by the EP *Trust* in 2016. Dena is currently working on her new album. She lives in Berlin. P. 57 • DIANA CHEN was born in Taipei and grew up in Montreal. She now lives in Paris, where she works for a major fashion label. She travels a lot, loves good food, and likes spending time with her dog, Devo. P. 164 • DIMITRA ZAVAKOU is originally from Greece and now lives in Berlin with her family. She is the founder of Little Popup, a platform for children's fashion, workshops, and art. P. 102 • ELIF BATUMAN is a writer and journalist living in New York City. She writes regularly for the *New Yorker*. Her novel *The Idiot* was published in 2017. P. 75 • ELISABETH RANK is a writer living in Berlin. She is the author of the books *Und im Zweifel für dich selbst* and *Bist du noch wach?* See her blog, lisarank.de, for more. P. 198 • EMILY HASS is an artist living and working in New York City. P. 149 • EMMA PATERSON works as a literary agent at Rogers, Coleridge & White and lives in London. P. 8 • ERICA JONG is a writer living in New York City. Her novel *Fear of Flying* brought her renown in the 1970s. She has written many books since, most recently her novel *Fear of Dying* (2016). P. 129 • FRAUKE GEMBALIES is a designer with her own label, Gembalies. She lives in Paris and Berlin. P. 170 • GILLIAN HENN is a casting director and lives with her family in Berlin. P. 37 • HANYA YANAGIHARA is a writer and journalist. Her novel *A Little Life* was an international success. She is editor-in-chief of *T* magazine and lives in New York City. P. 58 • HARUKA HORI is from Japan. She works at the Alpes wine bar in Toyama, and previously worked at Beard restaurant in Tokyo. P. 35 • HEIDI JULAVITS is a writer living in New York City. Her book *The Folded Clock: A Diary* was published in 2015. She created the book *Women in Clothes* together with Sheila Heti and Leanne Shapton. P. 124 • IMKE JUROK is a freelance art director living in Hamburg. P. 13 • ISABEL PALMER studied political science in Paris. She recently moved from New York to Tokyo with her family. P. 190 • ISABELLA POTÌ is a chef at Bros restaurant in Lecce, Italy (www.brosrestaurant.it). P. 172 • ISABELLE GRAEFF studied at the Düsseldorf Art Academy and Central Saint Martins College in London. She is a photographer and lives in Berlin. Her work has been shown in numerous exhibitions. See isabellegraeff.de for more. P. 183 • JACKY COLLISS HARVEY is a writer, commentator, and cultural historian who writes and lectures on the arts and their relation to popular culture. She is the author of the best-selling *Red: A History of the Redhead*, and of the forthcoming *The Animal's Companion*. She has also worked as an artists' model, a film extra, and for over twenty years ran a succession of museum publishing programs. P. 95 • JANIS NACHTIGALL is a freelance architect. She lives in Berlin. P. 197 • JASMIN SCHREIBER runs her own PR agency for artists and lives

in Berlin. P. 28 • JESSICA AIMUFUA is a freelance writer, editor, and translator, and lives in Berlin. P. 97 • JINA KHAYYER is a freelance writer and journalist living in Paris. Her book *Älter als Jesus oder Mein Leben als Frau* was published recently. P. 194 • JOANA AVILLEZ is an illustrator living in New York City. Her drawings appear regularly in the *New Yorker* and the *New York Times*. Together with Molly Young she wrote the book *D C-T*, published in 2018. P. 135 • JULIA KNOLLE founded one of the first fashion blogs in Germany in 2007. She worked at *Vogue* for several years and cofounded the online magazine *hey woman!* She lives in Berlin. P. 60 • JULIA WERTZ is a professional cartoonist and amateur historian. She has published six graphic novels including *Tenements, Towers, and Trash: An Unconventional Illustrated History of New York City*. She does monthly comics and illustration for the *New Yorker* and *Harper's Magazine*. P. 112 • JULIA ZANGE is a freelance writer living in Berlin. Her novel *Realitätsgewitter* was published in 2016. P. 72 • JULIANE WÜRFEL is studying photography and lives in Leipzig. P. 64 • JUMAN MALOUF is a writer living in England. Her novel *Trilogy of Two* was published in 2015. P. 16 • KAORI KUNIYASU is originally from Tokyo and now lives in Berlin with her family. She works as an illustrator and animation artist. P. 146 • KATE GROOBEY is a British painter and performance artist. She lives in Paris. Her pictures were recently shown in the solo exhibitions *I'm Made of Milk* in New York and *The Good Life* in San Francisco. See kategroobey.com for more. P. 47 • KATHARINA VON USLAR lives in Berlin. She runs the Uslar & Rai bookstore on Schönhauser Allee with Edgar Rai. P. 44 • KATHARINA WYSS is originally from Switzerland. She studied film direction, film studies, and philosophy. Her first feature-length motion picture, *Sarah joue un loup garou*, had its premiere in fall 2017. She is currently working on her next screenplay and lives in Berlin. P. 156 • KERA TILL is a freelance illustrator and lives in Munich. See keratill.com for more. P. 176 • KHETSIWE MORGAN is a DJ. She performs under the name DJ Doowap and lives in Johannesburg. P. 86 • LEANNE SHAPTON is a writer, illustrator, painter, and publisher living in New York City. She received the National Book Critics Circle Award for her book *Important Artifacts and Personal Property from the Collection of Lenore Doolan and Harold Morris*, which tells the story of a failed relationship in the form of an auction catalogue. *Women in Clothes*, which she created with Sheila Heti and Heidi Julavits, was published in 2014. P. 80 • LENA DUNHAM is a director, writer, actress, and producer. She created the series *Girls* and wrote the book *Not That Kind of Girl*. She lives in New York City. P. 53 • LILY BRETT is a writer living in New York City. Her novel *Lola Bensky* and the collection of stories *Only in New York* were published in recent years. P. 105 • LINA MUZUR is an editor at Aufbau Verlag and lives in Berlin. P. 161 • LISA FELDMANN is a journalist and writer,

and has been the editor-in-chief of magazines such as *Cosmopolitan* and *Annabelle*. She founded the German version of *L'Officiel*. She lives in Zurich and Berlin. P. 91 • LUCA GAJDUS works as a model and lives with her family in Berlin. P. 24 • LUISE STAUSS is an art director and picture editor. She runs Studio Stauss & Quint together with Ayanna Quint. She lives in New York City. P. 202 • MALIN ELMLID is originally from Sweden. In 2008 she launched the Bread Exchange project. Since then she has exchanged well over a thousand home-baked loaves of bread for things that inspired her. She writes about travel, food, and lifestyle and lives with her family in Berlin. P. 89 • MARA HELLMANN studied graphic design in Weimar, Maastricht, and Berlin and works in Berlin as a freelance graphic designer. P. 141 • MARGAUX WILLIAMSON is a painter, director, and film critic. She lives with her family in Toronto. P. 159 • MARGO JEFFERSON is a writer and journalist. She received the National Book Critics Award for her book *Negroland*. She lives in New York City. P. 118 • MARY SCHERPE founded the blog Stil in Berlin. She lives and works in Berlin. P. 32 • MELANIE DAL CANTON studied politics and was managing director at Andreas Murkudis. In 2012 she opened her store MDC cosmetic in Knaackstraße, Berlin, selling beauty products, accessories, and cosmetics. The exhibition *The Bathroom Chronicles* was originally held in her store. She lives with her family in Berlin. P. 138 • MILENA KALOJANOV spent her childhood in Bulgaria and has lived in Berlin for twenty-five years. She is a landscape architect, works on communications and marketing for the architecture firms Zanderroth Architekten and SmartHoming, and writes for Cee Cee Berlin. She is passionate about plants and gardens. P. 110 • MIRNA FUNK is a freelance journalist and writer. Her debut novel, *Winternähe*, was awarded the Uwe Johnson Prize. She lives in Berlin and Tel Aviv. P. 15 • NICOLE ARAGI is a literary agent and lives in New York City. P. 184 • NICOLE HOGERZEIL runs the store Schwarzhogerzeil on Torstraße, Berlin. P. 132 • NICOLE ZEPTER is a writer and journalist. She was editor-in-chief of *The Germans* and *Neon*, and wrote the book *Kunst hassen: Eine enttäuschte Liebe*. She has recently moved to the Frisian countryside. P. 153 • NIKE VAN DINTHER is one of the founders of the blog This Is Jane Wayne. She writes about fashion, music, photography, lifestyle, and design, and lives in Berlin. P. 54 • NINA BUSSMANN is a writer living in Berlin. Her novel *Der Mantel der Erde ist heiß und teilweise geschmolzen* was published in 2017. P. 166 • NINA ZYWIETZ lives and works as a freelance creative director in Berlin. Her book *The Germans*, written together with Silke Wichert, was published in 2017. P. 66 • ORIANE BAUD grew up in France and Switzerland. She writes about fashion, works in art direction, and creates collages. She lives in Berlin. P. 193 • PAULINA CZIENKOWSKI is a freelance journalist. Her work has appeared in publications including *Die*

Welt, Welt am Sonntag, the *Berliner Morgenpost*, *Zeit* magazine, and the *Frankfurter Allgemeine Sonntagszeitung*. She lives and works in Berlin. P. 83 • PHILOMENE MAGERS is a cofounder of the Galerie Sprüth Magers. She lives and works in Berlin. See spruethmagers.com for more about the gallery. P. 39 • RIKKE GERTSEN CONSTEIN is global art director at Sony. She works in Lund, Sweden, and lives in Copenhagen and Berlin. P. 142 • ROZ CHAST is a cartoon and comic illustrator and lives in New York City. Her drawings regularly appear in the *New Yorker*. Her book *Can't We Talk about Something More Pleasant?* won the National Book Critics Circle Award. P. 23 • SABINE HAVERKÄMPER is a pediatrician and lives with her family in Berlin. P. 136• SABRINA DEHOFF is a designer. She studied at the Royal College of Arts in London and worked as an assistant to Alber Elbaz and Cristina Ortiz in Paris. In 2010 she opened her own jewelry store in Berlin. Today it is located in Auguststraße, in the Mitte district. P. 21 • SADIE STEIN is a freelance writer for publications including the *Paris Review* and the *New York Times*. She lives in New York City. P. 101 • SARAH BUSCHOR works for the Villa Grisebach auction house and lives in Munich. P. 186 • SARAH ILLENBERGER is an artist, illustrator, and designer, and lives in Berlin. See sarahillenberger.com for more. P. 120 • SARAH RALFS is a theater expert and occasionally also appears as an actress. She lives in Berlin and has just finished a PhD on Christoph Schlingensief. P. 79 • SHEILA HETI is a writer. Her book *Motherhood* was published in 2018, and *How Should a Person Be?* in 2014. She also published the book *Women in Clothes* with Heidi Julavits and Leanne Shapton. She lives in Toronto. P. 63 • SHOU AZIZ is a cultural studies expert living in Berlin. P. 163 • SIMONE BUCHHOLZ is a writer and freelance journalist living in Hamburg. Her novels *Blue Night* and *Beton Rouge* were published recently. P. 144 • SONJA HEISS is a filmmaker and writer. Her motion pictures *Hotel Very Welcome* and *Hedi Schneider steckt fest* have won multiple awards. Her collection of short stories *Das Glück geht aus* was published in 2011, followed by the novel *Rimini* in 2017. She lives in Berlin. P. 69 • STEFANIE LEIMSNER works as a freelance press and events coordinator in the publishing sector. She lives with her family in Munich. P. 93 • SUSANNE KIPPENBERGER is a journalist and writer for *Tagesspiegel*. Her book *Das rote Schaf der Familie. Jessica Mitford und ihre Schwestern* was published in 2014. She lives in Berlin. P. 117 • SUSANNE STEHLE studied theater arts. She works in the costume department of the Bavarian State Opera in Munich. P. 169 • THERESIA ENZENSBERGER is a freelance journalist and writer. She founded *Block* magazine in 2014. Her first novel, *Blaupause*, was published in 2017. She lives in Berlin. P. 122 • THI-NGOC THAI is originally from Vietnam. She works for Camper and lives in Berlin. P. 201 • VANESSA FUENTES is a photographer. She and Nada Lottermann

are the duo behind Lottermann & Fuentes. She lives in Frankfurt. P. 131 • VERENA GÜNTNER studied drama in Salzburg and now works as a freelance writer. Her debut novel, *Es bringen*, was published in 2014. She lives in Berlin. P. 48 • VERONIKA HEILBRUNNER was an editor at *Harper's Bazaar* and founded the online magazine *hey woman!* together with Julia Knolle. She lives in Berlin. P. 179 • VICTORIA ELIASDÓTTIR is originally from Iceland. She is a chef and lives in Berlin. P. 108 • YUJIN LILY SEO looks after her family and lives in Bangkok with her husband and daughter. P. 206 • ZSUZSANNA TOTH is an editor, writer, and freelance consultant living in London. P. 205